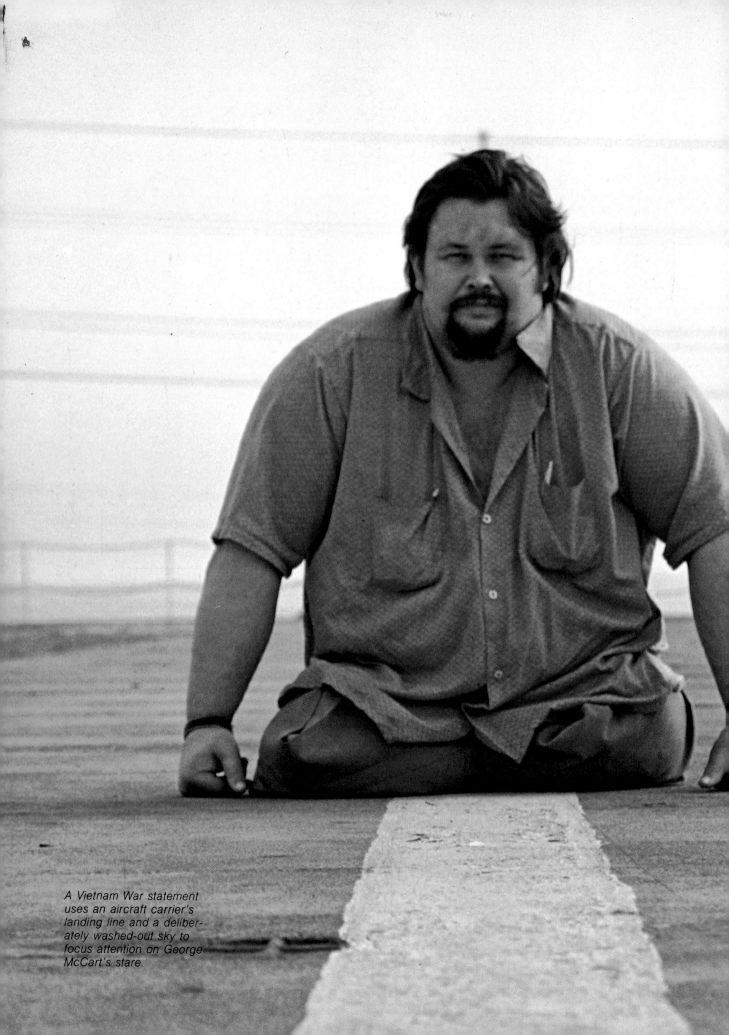

A Vietnam War statement uses an aircraft carrier's landing line and a deliberately washed-out sky to focus attention on George McCart's stare.

the Persuasive Image: Art Kane

text by John Poppy
with the editors of Alskog, Inc.

Prepared by Alskog, Inc.
Lawrence Schiller/Publisher
William Hopkins/Design Director
John Poppy/Executive Editor
Sean Callahan/Editorial Coordinator
Ira Fast/Production Manager
Julie Asher Palladino/Design Assistant
Judith R. Schiller/Copy Editor
Lou Jacobs, Jr./Technical Editor

An Alskog Book
published with
Thomas Y. Crowell Company, Inc.

Alskog, Inc., 9200 Sunset Boulevard, Suite 1001
Los Angeles, California, 90069

Library of Congress Catalog Card Number: 75-12856
ISBN: 0-690-00784-1 Soft cover
ISBN: 0-690-00783-3 Hard cover
First Printing
Published simultaneously in Canada
Printed in the United States of America

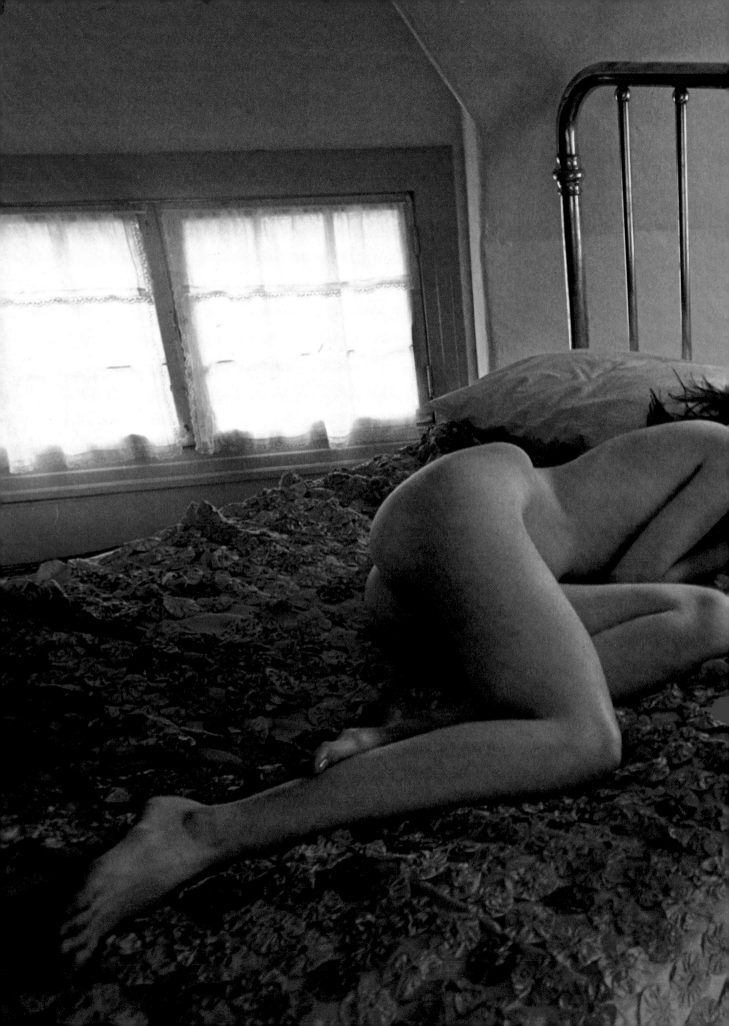

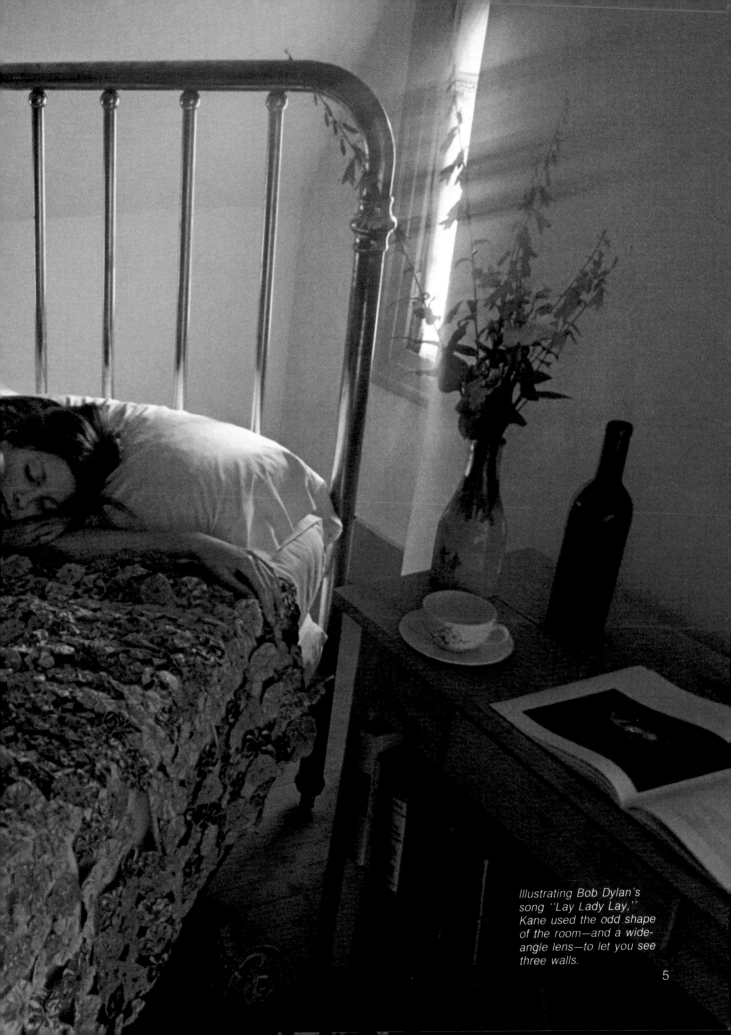

Illustrating Bob Dylan's song "Lay Lady Lay," Kane used the odd shape of the room—and a wide-angle lens—to let you see three walls.

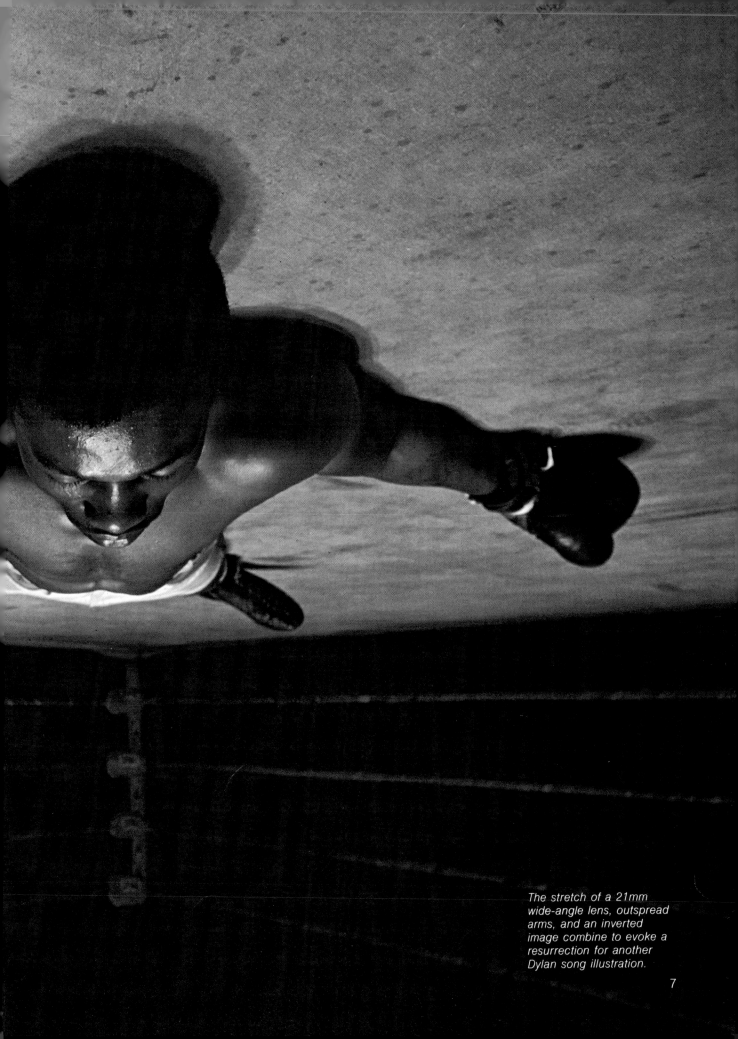

The stretch of a 21mm
wide-angle lens, outspread
arms, and an inverted
image combine to evoke a
resurrection for another
Dylan song illustration.

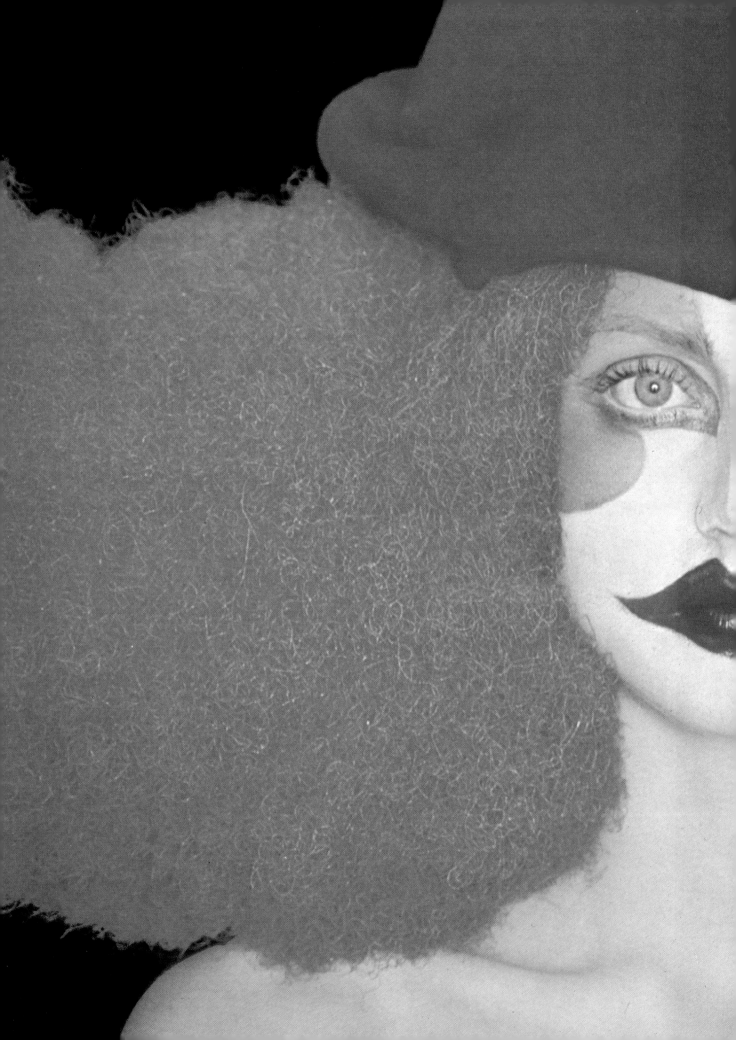

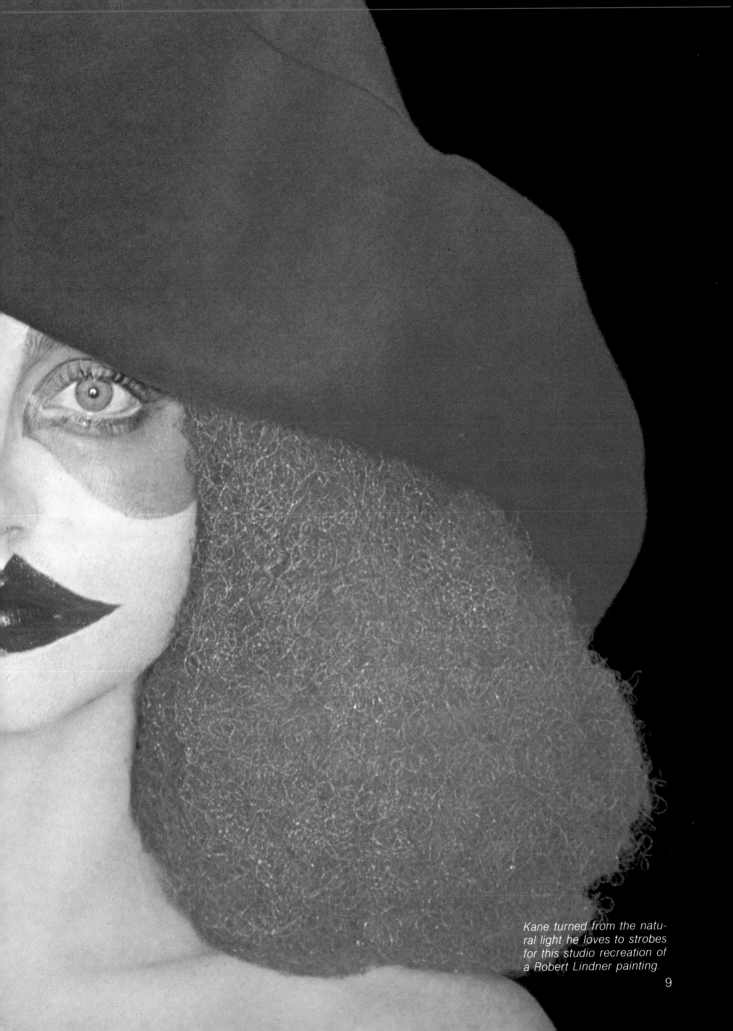

Kane turned from the natural light he loves to strobes for this studio recreation of a Robert Lindner painting.

9

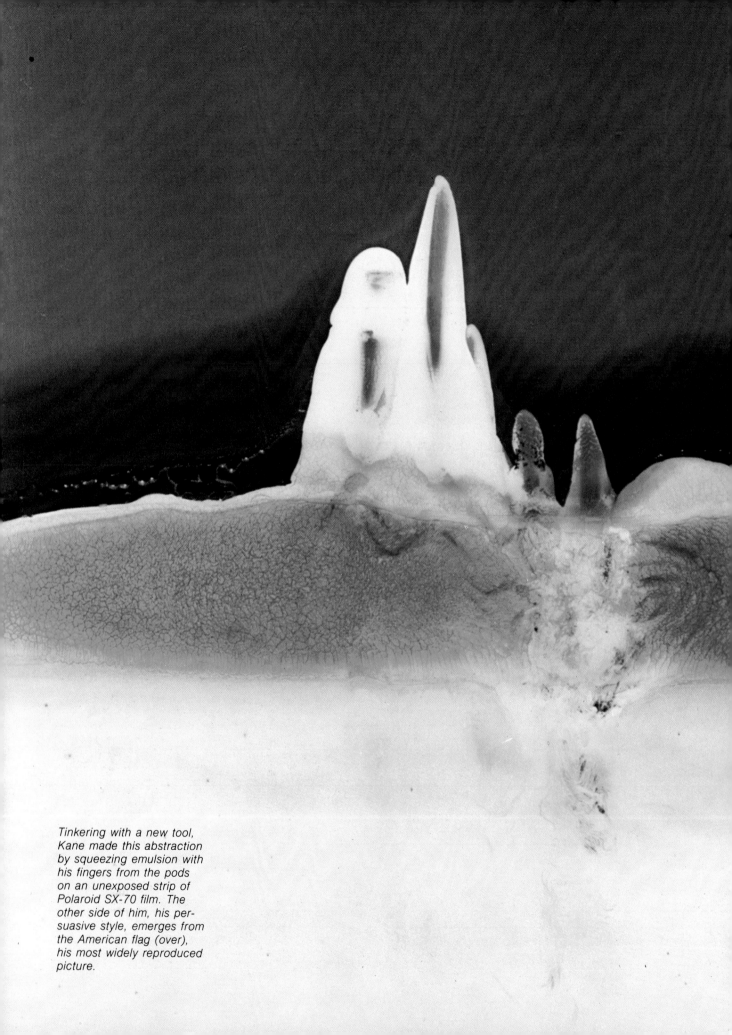

Tinkering with a new tool, Kane made this abstraction by squeezing emulsion with his fingers from the pods on an unexposed strip of Polaroid SX-70 film. The other side of him, his persuasive style, emerges from the American flag (over), his most widely reproduced picture.

Introduction

It has been more than a century since some users of the camera, drawn by an urge to stir the imagination and call to the will, began seeking ways to transcend the "realism" of their medium.

Four years after Louis Daguerre revealed his process in 1839, John Edwin Mayall of Philadelphia made 10 illustrations for the Lord's Prayer, and other experimenters soon pushed photography deeper into allegory. In 1858, Henry Peach Robinson's famous picture, *Fading Away,* showed a dying girl attended by sorrowing parents—all of them models, all arranged for poignant effect. The Victorian English were shocked by the poor taste of it all, even though painters of the time dealt with far more violent subjects. Photographers, it was assumed then (as now), deal with literal truth; so the scene was seen as heartless reality.

Yet such pictures included painstaking artifice. Robinson made *Fading Away* with five negatives, carefully masked and combined in the final print. "Any dodge, trick, and conjuration is open to the photographer's use," he wrote. "It is his imperative duty to avoid the mean, the bare and the ugly, and to aim to elevate his subject. A great deal can be done . . . by a mixture of the real and the artificial in a picture." Julia Margaret Cameron, one of the greatest of all portraitists, began in the 1860s to use costumes and even lenses built with deliberate defects to destroy some detail "in recording faithfully the greatness of the inner as well as the features of the outer man." Not coincidentally, she spent much of her time with the great storytellers of her time, among them Tennyson, Browning, Longfellow and Darwin. Writers, in fact, seemed especially drawn to the new medium: Charles Dodgson (Lewis Carroll), Samuel Butler, Oliver Wendell Holmes and others were amateurs.

Thus the foundation was laid for some photographers in the 1950s to begin making commercial use of imagination, color, and a confidence that ideas could be translated into images that argue for some point of view. Perhaps the most influential among them has been Art Kane, whose intuitive and technically brilliant use of color and design has affected a generation of photographers who now take it for granted that they can function not just as recorders but as interpreters in pursuit of an ideal vision. Kane's earliest portraits for magazines such as *Look, Life* and *McCall's* gather power from his ability to "edit out the little and ugly and emphasize the big and heroic," to record the kind of picture we usually compose only in memory. In both advertising and editorial work, he uses montage—kin to the early multiple prints—and more modern techniques to make an image speak not just of what is, but of what could be.

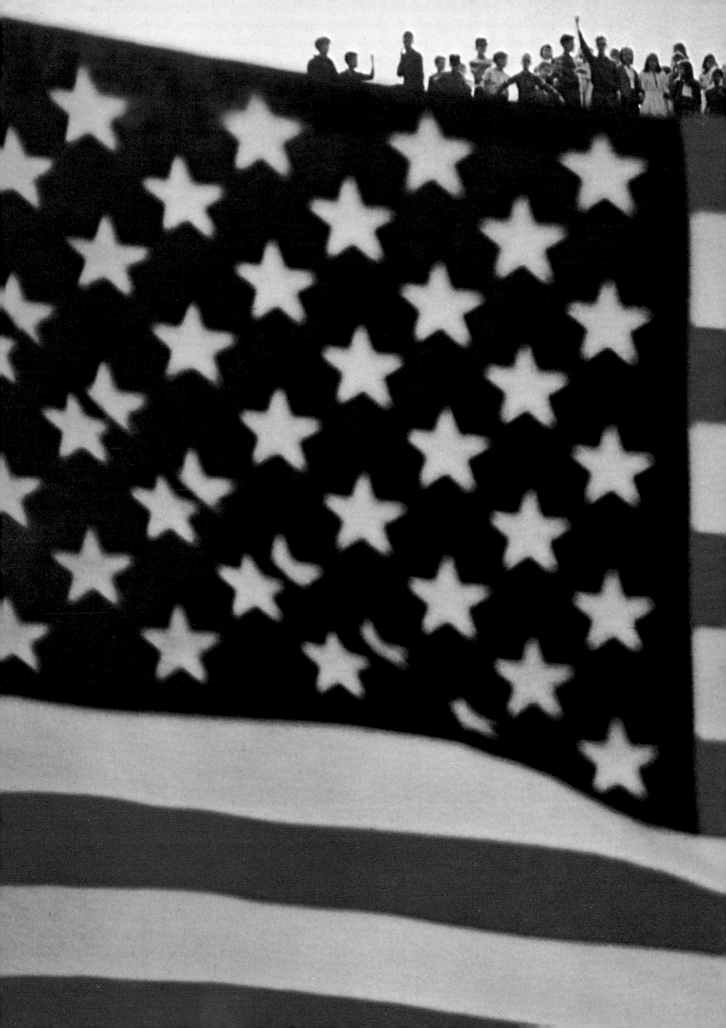

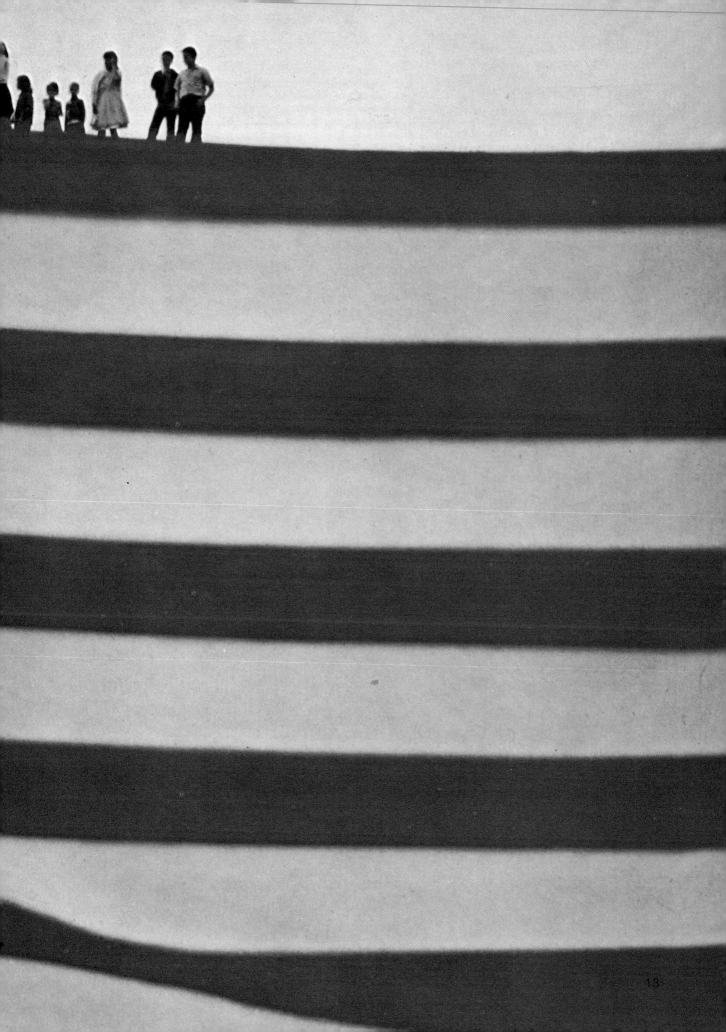

A Visionary's Revenge on the Camera

When the weather was bright and soft, as it was on this Sunday afternoon, the family liked to go to the zoo. It was easy; they lived in the Bronx, home of the best-known zoo in New York and perhaps the entire United States. There the children, their parents and aunts and uncles strolled, chewing Crackerjacks, feeding llamas, teasing monkeys, growling back at lions, holding their noses through the elephant house.

Then they gathered at the base of a flagpole in front of the sea lions for the family portrait that always climaxed these excursions. The ritual was almost over when the youngest boy, Arthur, cast a bored look upward and saw something that made the blood lunge to his cheeks.

Soaring against the clear blue sky was a brilliant American flag. The size of it! The colors! Today young people may burn it, make clothes of it, change its stripes to ecological green, but to a 12-year-old in 1937 that flag was Old Glory, fruited plains and purple mountains' majesty, an orchestra playing ''America the Beautiful'' in his

Kane at play on a fashion assignment in India.

head, a rush of emotion. He had to preserve it all.

''Dad, can I please borrow your camera?''

''What for?''

''The flag.''

''Okay. There's one more shot, make it good.''

He stood at the base of the pole, squinting up into the viewfinder. Holding his breath, he pushed the shutter release.

All week he waited for the film to come back

from the drugstore. The night his father brought it, the family gathered around the kitchen table. Arthur strained to get a look at his shot. One, two, three, four, five, six, seven identical family photos. What a bore. Then the eighth picture: a pure white rectangle divided up the middle by a line that diminished to a pinstripe near the top where, if you looked hard, you could see a

tiny speck.

''That's not my picture!'' Arthur cried. ''That's not what I saw! Are you sure that's the last one?''

That absurd speck was it, all right. Only it was not what Arthur had seen. It was what the *camera* had seen. The realization infuriated the boy. Shredding the print, he cursed the machine that could reduce a moment of grandeur to

nothing, and vowed never to take another picture as long as he lived.

One spring morning 35 years later, a childhood girl friend telephoned, calling him ''Artie,'' to ask if she could drop by just for old times' sake. His name at advertising agencies and magazines since the early 1950s had been Art Kane; nobody had called him Artie since he turned his back

on the Bronx and headed downtown.

On the day of the appointment, his secretary let her into the high-ceilinged studio above Carnegie Hall. He stood up from his caned swivel chair as the visitor glanced at his marble-top desk, at the secretary's electric typewriter, at the props standing around like a collection of found art, at looming canvas flats and rolls of seamless paper, at an assistant opening boxes of Kodachrome in front of a wall covered by color prints of Kane's favorite photographs. Many were famous: the little crowd supported by their awesome American flag, Venice being swallowed by the sea, the fists of Joe Louis. Some, like a portrait of a young black man behind a web of steel—or is it behind him?—had changed people's lives. Every one of the images delivered a message, and in their hot persuasiveness they spread out on that wall the joys and dreads and passions of Kane's own life.

Hands on hips, she turned to him. ''*Ahtie!*'' she exclaimed. ''Ya gotta real nice business!''

Indeed. Kane had just returned from a fashion job with Jean Shrimpton in India, where one of the world's most desirable models had snapped a picture of one of the world's most desired photographers playing atop a painted elephant (far left). That sort of thing is fun—the business can take him to any part of the world that he wants to visit—and so is seeing the buttons on the studio telephones winking softly with calls from art directors hoping to persuade Kane to put his touch on a sales campaign. Cigarettes? Soft drinks? Banking services? Supersonic aircraft? Call Art Kane.

Still, the intended compliment drew a cold stare, a perfunctory lunch in a dark restaurant and a fast good-bye from Kane. A nice *business?* Okay, the income was obviously in six figures, but he would rather have heard, ''Ya gotta real distinctive point of view.'' Couldn't she see what a haven the studio was for the introspective man who thought up all those pictures in his head before he picked up a camera? No. She didn't know that the ads are done to finance his true love, the editorial illustrations that return again and again to the loneliness and expectant spirituality of a man who remembers every voice, every smell, every new shiver of sex in his youth—and who has been working for years to move to some real beyond.

Back then as she stood in his studio, magazines like *Look* and *Life* were still alive, still able to spend thousands of dollars to build Kane a set or fly him across the country. They—and *Esquire, Vogue, McCall's*

and others—did it because they knew they would get more for their money from Kane than they could ever expect from some less choosy, more docile photographer. Some of his opportunities for editorial illustration died with the big picture magazines. He has recently experimented with new outlets for such work, as we shall see, but his attitude has not changed. Once he accepts an assignment, art directors know Kane's pictures will make *his* personal statement in a way that solves *their* problems.

''Whenever he does something for me,'' independent art director Herb Lubalin told photo critic Jacob Deschin for an assessment of Kane in *Popular Photography,* ''I try to stay out of his way. Most of the time he gives me back something better than I asked for. . . . He has something that few other photographers have. He excels not only as a photographer with perception but also in having a point of view.''

In finding that point of view, Kane has been as ruthless with himself as he is with transparencies

Art Kane and friend Jean Pagliuso.

that don't quite work (he flips them into a trash barrel). In the past couple of years he has been a busy and vivid writer, jotting down scenes for an autobiography that, if ever published, could make him the Philip Roth of photographers. His unwary visitor took a lashing in one such scene that, as Kane intended, reveals more about him than her:

''My entire philosophy spread out on that wall,'' he wrote, ''and she stands there with this ugly dress and her fat legs spread apart and her fat hands on her fat hips. . . .''

Instead of bottling up his fury he wrote it down, along with a prejudice that he has long held and is now trying to dissolve by showing it to the world, this distaste for women who do not measure up to his standard of beauty. Until recently, Kane could not tolerate pores or visible veins on any woman he might photograph. ''The Draw-a-Model pictures I traced as a boy never had blemishes,'' he recalls. ''They were just outlines on nice smooth paper. The Petty and Varga girls never had them, they had skins made of airbrushed pigment.'' He regards it without regret or defense, simply as a condition he is trying to get rid of. After two marriages, he met Jean Pagliuso, a photographer whose dark, tousled vivacity moved one Kane-watcher to announce, ''She even *looks* real.'' She recently moved from Los Angeles to New York to share his Gramercy Park apartment.

Now it is early 1975, and Kane is in several kinds of transition. He is returning to full-time commercial photography after a year's attempt to move away from it. The builders have not completed his new studio in lower Manhattan. Jean is away on the West Coast, leaving their apartment feeling empty. So we are sitting by a stone fireplace two and a half

A break in a bathing-suit take.

hours by Porsche north of New York, drinking tea and watching the snow fall outside Kane's country house in the Catskill Mountains. The house, built in 1901, has the feel of a big summer cottage, which it was for the family who commissioned it. Set on 30 wooded acres, it is airy, full of open spaces and light from tall windows all around, and has served Kane since 1965 not only as a retreat but as a picture location.

He found the house while skiing in the region. Exercise certainly shows in the well-muscled six feet of a frame that looks, like his face, as if Kane had been born in 1940 instead of 1925. He expects his two sons, Jonathan and Anthony, to drop by later with some members of their blues band ("The Kane Brothers—they really sound good, and that's not just because I like my boys so much"), but for now he is willing to talk about what it is that gives his pictures their distinctive flavor. Coming from the big man in cowboy boots through a set of teeth so strong and cavity-free that a cast of them is stored—no kidding—at the Smithsonian, the voice is a light baritone, almost sing-song as it curls around a New

York accent on its quest for insight.

The photographs, it soon becomes clear, are the fully realized fantasies of a person Kane himself calls "a poor bastard for whom the real world just doesn't look good enough."

He admires the work of reporters such as Bruce Davidson, Henri Cartier-Bresson and W. Eugene Smith, yet "Reality never lives up to itself visually for me. I'm less interested in recording than in sharing the way I feel about things." Just being there is never enough. Kane's approach to photography is intellectual, not journalistic, so his pictures reflect ideas about subjects that interest him—popular culture, a bit of fashion, social upheavals. He recreates in a camera what the little boy really saw at the top of the flagpole.

Literally. Kane loves to photograph the American flag. His most widely published image is the one on pages 12–13, printed originally in *Look* to illustrate the preamble to the Constitution: "We, the people . . ."

He muses, "Maybe I photograph the flag so much to get revenge on the machine that disappointed me so badly in the Bronx Zoo that day, to say, Okay, you son-of-a-bitch, you're going to work for me." The adult Kane responds more to the flag's graphics than the 12-year-old Kane's patriotic fervor. "It seems to have been

made for the wind. The Japanese flag, with its red circle, is impeccable and I think unfurled it is the most beautiful flag in the world, but it does nothing in the wind. Nor do the flags with little crests and triangles. But those 13 stripes and that mass of stars *move* so beautifully."

The assignment came as Kane was experimenting with the 21mm lens that had just been developed for single-lens reflex cameras. He had already startled the conservative world of fashion by using the 21mm to stretch a picture toward the edges of the frame, as in the pioneering image in the middle of page 47. (Like a number of his innovations—an especially potent use of montage, selective focus, a knack for turning pictures upside down or sideways—the close-up craziness of wide-angle caught the fancy of both professionals and advanced amateurs, and Kane eventually moved on to other techniques.) But this time he was after another property of the 21mm, its extreme depth of field.

He wanted to combine excitement and majesty with a feeling of the flag as the land that supports us, the people. From his

Jonathan, Art, and Anthony Kane.

mental file of locations, out popped a memory of the pearly light on a hill behind a house he once rented in western Connecticut. Kane stationed a group of young people on the crest of the hill. About 75 feet downslope he suspended the flag, a standard 3′x5′ size, between two poles and set a Nikon on a tripod just close enough to crop the poles out of the frame. The day was bright, so he could have stopped down the lens enough to keep foreground and background quite sharp, but to suggest some movement he chose to throw the flag slightly out of focus.

Kane's reputation as a master of montage prompts many people to assume that he made the picture by sandwiching two separate images, but a close look at the blue behind the stars reveals an outline of the hill. The impact of the illusion blocks that detail from the mind.

The satisfaction Kane draws from a picture years after making it, as opposed to his boredom with another equally famous one, has more to do with its statement—the point of view toward which he is trying to persuade a viewer—than with its science. He admits that he knows what to do to find a simple, dramatic solution to a conceptual problem,

but technical talk bores him.

Not only did he grow up never dreaming that he would be a photographer, he loathed the idea. He spent his childhood on Vyse Avenue in the East Bronx, the younger of two sons in a family of Jews who had escaped the Czar's pogroms in the Ukraine.

His father stopped calling himself Kanofsky on the day he got his citizenship papers in 1932 and chose a variant that might make it easier for him to join the mainstream of his new country: Kane.

Artie Kane went into adolescence fascinated by girls and snakes and the processes of his own mind, but repelled by photography. Besides the flagpole fiasco, he found that anything to do with

Art (in tree) and brother Seymour at the Bronx Zoo in the year Kane took his first flag picture.

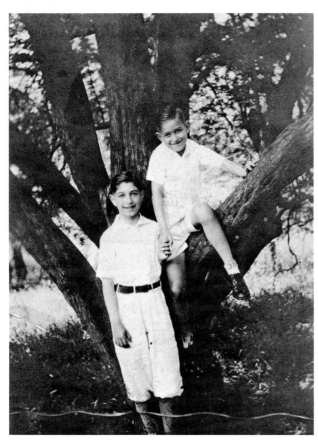

chemicals or science scared him witless. A friend named Bradley had a darkroom "and a big brain. He was the kind of guy who couldn't just go into a stamp store and buy a stamp; he'd have to spend hours talking to the man about the quality of the glue on stamps from Serbia. I used to hate him for his curiosity, and I knew I could never, never do the stuff he did in his darkroom."

Instead, Kane wanted to be an illustrator like N.C. Wyeth and Norman Rockwell. After graduation from high school he was accepted at the Cooper Union School of Art in New York, where he finished one semester—"With no particular originality, just average"—before World War II began and he was drafted.

Kane volunteered for a camouflage battalion. He found himself in a unit with a number of men

who would later become well-known artists, including the fashion designer Bill Blass and the hard-edge painter Ellsworth Kelly, all of them expecting to spend the war quietly designing sniper suits and painting shadow patterns on the sides of trucks. They discovered that they had volunteered for a suicide mission.

They landed in France soon after the June 6, 1944, invasion of Normandy. Their top-secret job was to decoy German attacks away from American divisons. To do it, they had created an inflatable rubber army of tanks, trucks, and big guns. In the middle of the night they would pull into an area that a real Allied division of, say, tanks had just vacated, then pump up their rubber tanks, conceal them just badly enough to make them visible, play records of engines grinding and treads clanking, and bustle around making as much of an impression of size as they could—all the while acting as sitting ducks for enemy attacks on their balloon army. A gasoline can under each replica had to be exploded immediately if a German bullet should start letting the air out; it wouldn't do to have the barrel of a long gun wilting like a broken toy. Many times the Germans were attacked from the rear by a real division while concentrating their fire on Kane and his friends in front of them.

Returning to Cooper Union somewhat matured, Kane was no longer just average. He was graduated in 1950 with straight As. During his last year he bought a Ciroflex 2¼x2¼ camera for a required photo class, and discovered with amazement that he no longer dreaded taking

pictures. He had a job designing layouts at *Esquire* during that last year and fell in with a group of designers who liked to go out, shoot, and then compare results. The first weekend Kane went out with another designer, Henry Wolf, and illustrator Bill Charmatz, he spent 30 minutes composing one picture and had an experience that was almost religious.

In brilliant sunshine near a lighthouse station at Provincetown, Mass., Kane draped a jacket over his head and viewing screen. He realized suddenly that he was in complete control. The only light allowed into his little chamber came through the viewer; the only vision occupying his mind at that moment appeared on the same small rectangle.

"I realized that photography wasn't merely the act of selection, but is equally an act of rejection, deciding what you will not allow in," he remembers of that day. "I was very proud of myself. I knew I had overcome a prejudice. This instrument that I had thought about with contempt all those years now proved to be almost a friend—or if not a friend, at least a collaborator that didn't dominate me."

Kane soon became art director at *Seventeen* magazine. His designs won prizes six years in a row until he decided—as he has done several times since—that he had reached his peak and had to jump into something different. He joined the Irving Serwer Agency, a small and excellent fashion advertising house (now defunct) as an art director. He had made occasional photographs for *Seventeen,* and during his three years at Serwer he published some in photo

magazines. But it was not until he shot a full-blown assignment for *Esquire* (pages 38–39) during a two-week summer vacation in 1958 that he decided on a second dramatic change. He would break away and devote himself to photography. A gold medal from the New York Art Directors' Club for the *Esquire* pictures clinched the decision.

No matter what spectacles the camera has helped him record in the years since, his attitude toward it has changed only slightly. He treats it with respectful contempt. He likes to handle it and knows that if he breaks it, it won't perform for him, so he has assistants constantly checking its condition. But he also abuses it, cleaning lenses with a handkerchief instead of lens tissue, wiping grease on a lens or even spitting on it—"anything that will produce results, whether it's good for the camera or not."

What Kane has loved from that first moment at Provincetown is "the ritualistic aspect of the medium, the embryonic feeling of being lost in the magic window of the viewfinder, the incredible comfort of being in the temple I made under my jacket. I looked sort of ridiculous when I started using 35mm cameras, because nobody ever used a hood with one of those, but I kept doing it for a while because I really loved the alienation, being totally removed from the outside world, like having my own mini-theater."

The hood is long gone; he learned to block out intrusions mentally. Yet his photographs to this day retain a sense of concentrated wonder, projecting visions that are in every respect controlled by Kane's inner vision.

Portraits: Using Color and Environment

Art Kane's photography business consists of two parts: the "applied" work of advertising, and the more poetic, personal sharing of ideas in editorial illustration. They feed each other.

When Kane shoots an advertisement—usually one of the most rigidly monitored situations a photographer can get himself into—most clients

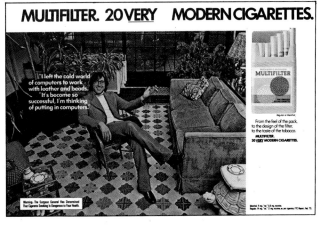

know to leave him alone. On a recent cigarette campaign, for instance, the Multifilter people told him they wanted a relaxed, non-model type like football star Joe Namath, and then left the choice to Kane. After four days of casting, he still had not found a model who looked right. On the fifth morning, he was wiping the last bit of shaving lather from his face, staring into the mirror, when he suddenly realized, "That's

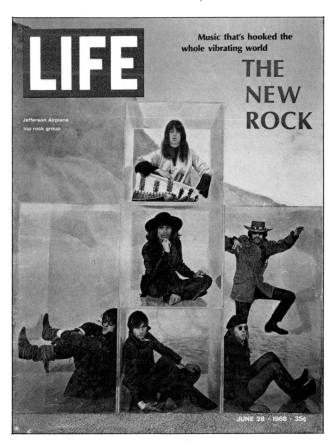

the guy." Later that day, after a moment of shock—big-time photographers rarely cast themself in ads—the client agreed and set him up in a leather suit. Kane put his motorized Nikon on a tripod, had his assistant sit in as he designed the picture, and then "just got in there and had them click off the rest of the roll."

Such confidence, in both client and photographer, grew as it became obvious over the years that Kane's editorial illustrations speak across generations and cultures, bridging emotional and geographical gaps. As an illustrator, he can convey to a viewer the essence of an idea or a personality. As an advertising photographer, he can sell merchandise with similar techniques.

It is ironic that Kane photographed himself laughing in the Multifilter ad, for the faces in his pictures rarely show animation or emotion. Even in portraits, he makes the other elements of a picture carry the message.

When the editors of *Life* decided in 1968 that the cultural revolution spreading from San Francisco's Haight-Ashbury district could be examined through its music, they turned to Kane for a visual interpretation. *Life* reporter Robin Richman chose a

19

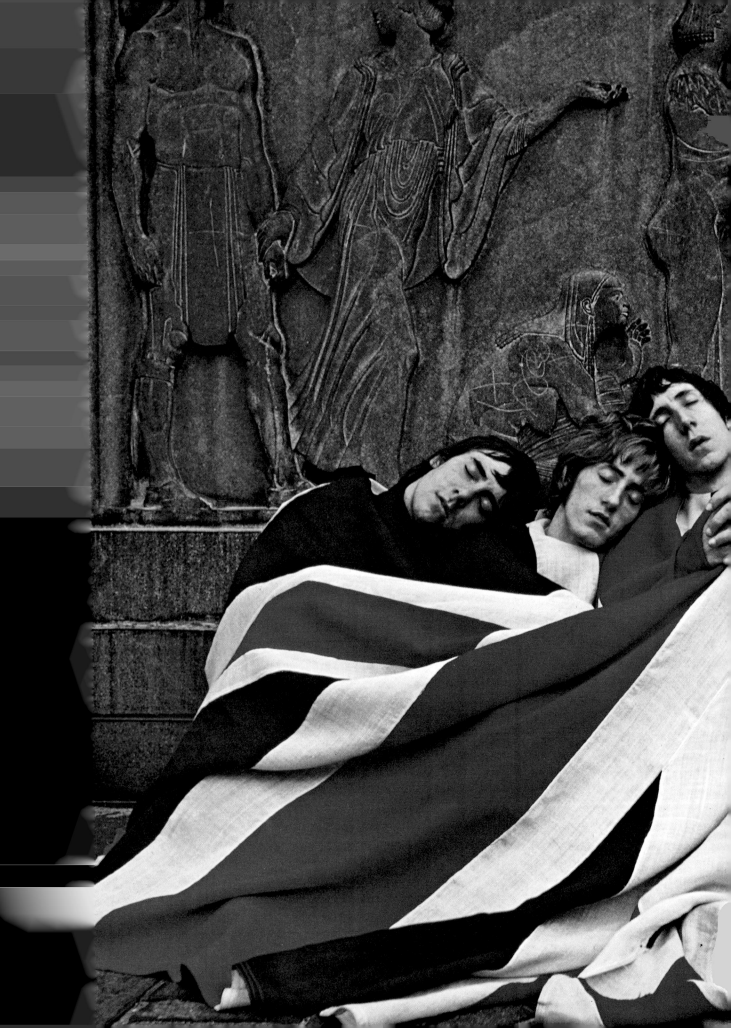

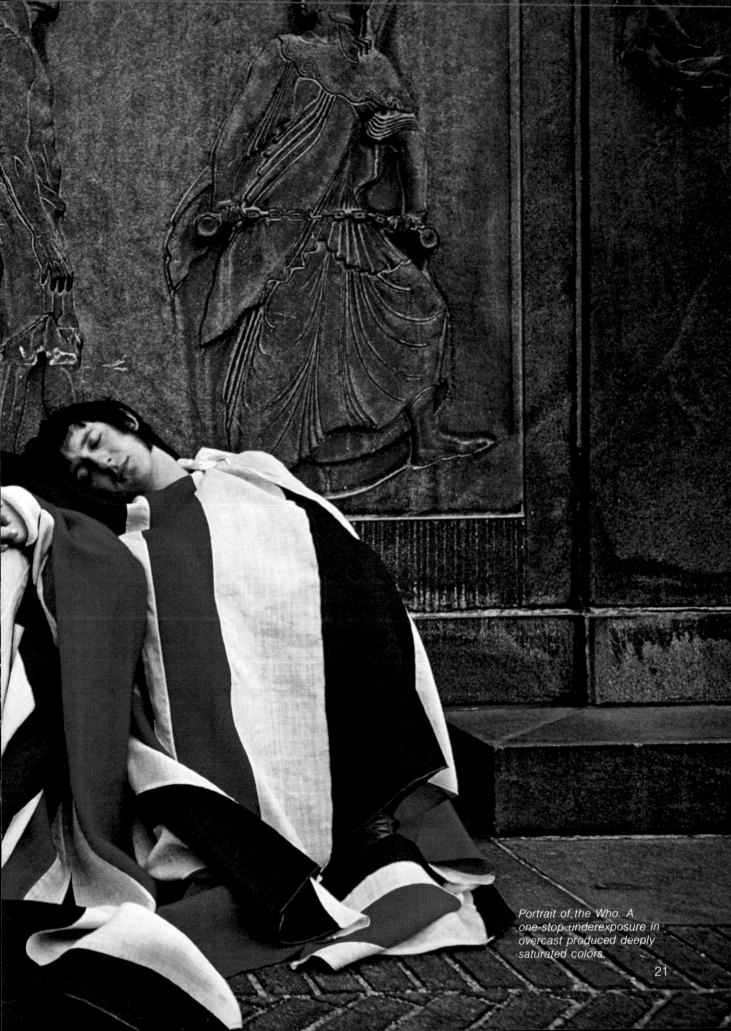

Portrait of the Who. A one-stop underexposure in overcast produced deeply saturated colors.

21

collection of groups that were creating "The New Rock" and presented her list to Kane. He then began to analyze his problem.

Each group had developed a personal style in both sound and message, each comprised individuals whose quirks affected the New Rock. How could Kane sum up what they meant to him? Performance shots would quickly become redundant; there were too many visual similarities. The performers all had long hair. They all dressed in costumes. They all used standard musical instruments to produce their sounds. As objects, then, they looked alike.

Strip them of their instruments and take them off the stage, Kane mused, and you can come to grips with them as people. Their minds become important. One by one, he began constructing portraits that would project what those minds meant to him. With his desire to reveal more than what appears on the surface, Kane has always felt that a face is never enough for a true portrait. Traditionally, portrait photographers manipulate light to reveal the structure of a face in some provocative manner, and in doing so, dominate the subject with their own style.

Staring at a fact sheet on the Jefferson Airplane and immersing himself in their sound, Kane began imagining an environment that would communicate unseen elements—attitudes, achievements, desires, ideas—as well as the appearance of this leading acid-rock group. Some of the early "portraits with symbols" by Irving Penn and Arnold Newman had turned his mind toward an "environmental portrait"

in which the face no longer has to carry the whole burden but can share it with other things. For the cover picture of the Airplane (page 19) Kane began by having six plexiglas boxes made at a cost of $3,000. "I could never get away with that today," he says, looking up from the fireplace with a laugh. "When *Look* and *Life* folded nothing replaced them. The time of the big editorial production is over." Expenses on this picture alone ran about $4,000, and Kane never left New York. That was pretty outrageous even for *Life*, but Kane points out that as an interpretive artist he has to spend money "because I create things from nothing." Reportage would have been cheaper, even if he had flown to the Airplane's base in San Francisco for at-home and performance pictures, but would not have given Kane a chance to persuade a viewer of the dimensions he saw in the Airplane.

"Flight is their fancy, flying by any means, drugs or fantasy," he wrote in a notebook, "to leave the ground, enter the rabbit hole . . . They seem to favor the look of the 'bad guy' in the old Western movies, in revolt against a condition brought on by the good guys."

His assistants stacked the plastic boxes in an environment suggesting a barren stretch of Western desert, in front of a mound of gypsum on the bank of New York's East River across from the Union Nations Building. The members of the rock group gathered on a softly overcast afternoon and looked for explanation to Kane, standing beside his tripod, his Nikon and his 35mm lens. "You're going to float,

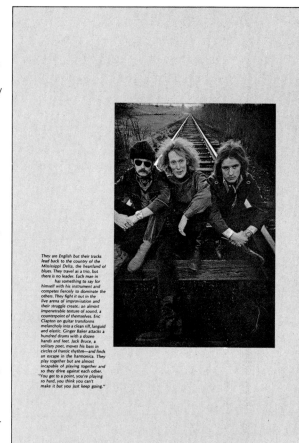

They are English but their tracks lead back to the country of the Mississippi Delta, the heartland of blues. They travel as a trio, but there is no leader. Each man in has something to say for himself with his instrument and competes fiercely to dominate the others. They fight it out in the live arena of improvisation and their struggle create an almost impenetrable texture of sound, a counterpoint of themselves. Eric Clapton on guitar transforms melancholy into a clean riff, languid and elastic. Ginger Baker attacks a hundred drums with a dozen hands and feet. Jack Bruce, a solitary poet, moves his bass in circles of frantic rhythm—and finds an escape in the harmonica. They play together but are almost incapable of playing together and so they drive against each other. "You get to a point, you're playing so hard, you think you can't make it but you just keep going."

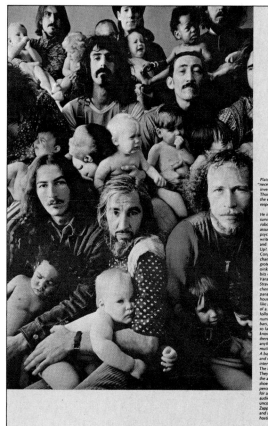

Plato made the statement that "necessity is the mother of invention" over 2,000 years ag[o] Thomas Edison responded with the electric light and Frank Za[ppa] responded with __ on Mothers Day, 196[?] He is eager to have the young survive society's plagues of pl[astic], robots, ugly radio, false morali[ty] assumes the role of musicolog[ist], psychologist and sociologist. [He] writes songs called America D[rinks] and Goes Home, Are You Hun[g] Up! and Who Are the Brain Po[lice?] Conglomerates of humor, sati[re], chance, nonfiction and the grotesque, punctuated with [?] oinks and bongs, sprinkled wi[th] bits of Motown, Sacco and Vanzetti, R & B, Rosemary de C[?] Stravinsky. "We're presenting [a] chemical monstrosity not rea[l] panacea. But it is a useful household preparation somet[hing] like ammonia." In the beginni[ng] of a song he will demand the following: "4/4 for a certain number of bars, then 17/8 for [?] bars, to 22/8 for one bar, all p[?] so fast and so tight you don't know what time it is." On stag[e] there is the "possibility that anything can happen." Dolls a[re] mutilated. A gas mask is displ[ayed]. A bag of vegetables is unpacke[d] and examined. There are space intervals of "honks" and soft[?] The Mothers perform Dead Air[?] They stop, sit down and ignore the audience. Zappa might ge[t] a shoeshine from Motorhead, the percussionist. They keep this g[oing] for as long as it takes the audience to become unsettled, uncomfortable and angry. The[n] Zappa calmly approaches the [?] and says, "It brings out the hostilities in you, doesn't it?"

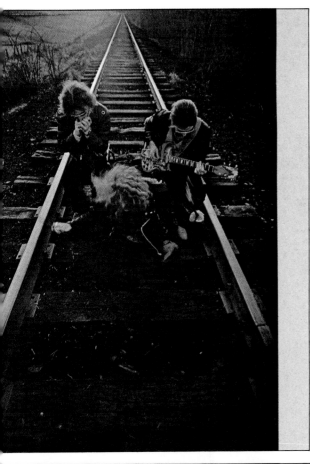

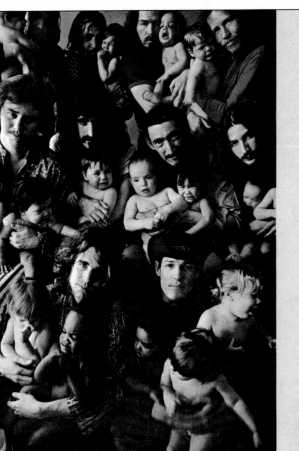

you're going to levitate," he told them, "you're going to appear together but apart, a little lonely, separated in your individual boxes." Above it all floated the group's high priestess, Grace Slick, on her throne of glass.

Kane exposed for their skin tones, slightly overexposing the gypsum and plastic so the fiercely intense Airplane stood out against a background of deliberately muted blues and grays. By contrast, he felt that the four English performers known as the Who were both irreverent—they not only thumbed their noses at the British Empire establishment but even smashed their own instruments on stage—and lovable in a devilish kind of way, like audacious children. How to show that? Leather jackets? No, too bullying. Pop-art clothes or Edwardian velvet and brocade? No, too vague. They needed to look bright, like a poster.

He remembered a dance called "Tent" that he had seen the Alwin Nikolai company do years before, in which Nikolai transformed his people into an everchanging single mass by enveloping them in a huge sheet of cloth. Poke the Who's heads through the Union Jack!

It all looked very flashy against white seamless paper in his studio, but after a few shots he held up his hand. "Stop," he said, and the lawless Who listened. "It's too sterile," he told them. "Let's go out and look for more environment. I want something to suggest empire and tradition and all that stuff."

"Right!" said the Who, and they all took to the streets. On the fringe of Harlem near the Columbia University campus they found a stone bas-

relief depicting warriors and slaves that a 35mm lens could frame behind the group (pages 20–21). Again, an overcast softened shadows and allowed Kane to expose for skin. But this time the colors of the flag jumped out from a dark background with precisely the raucous showbiz quality he had been aiming for.

"You've got to be careful of that brilliance," Kane cautions. "Color film is a flexible tool, but if you handle it indelicately you'll misrepresent what you're trying to say." He shoots almost exclusively in color, but not because he is just after pretty pictures. As an interpreter not a recorder, he is after an emotional truth.

As, for example, in the portrait on pages 2–3 of an amputee from the Vietnam War. "A battle scene has red blood and soldiers die on green fields, sometimes next to yellow flowers under bright blue skies. Very pretty. That doesn't add up to what it is like to have something tear your body apart. Color intrudes on the reality, just as it can make a reality, so you have to manipulate, wait for the light to change, or do something to keep that emotional truth. The way I've approached war is to digest the essence, and then spit it out."

So it was that in 1971 he made his picture of George McCart, who was working on a sciencefiction movie that featured several robots operated by amputees who could just fit inside. When the producer had asked Kane to do production stills, Kane said he wasn't interested—"and no magazine is going to publish dull pictures even if they are by me"—but was fascinated by the operators of the robots. Given complete freedom, he

would come to California and shoot what he thought somebody *would* publish. When he met the amputees, "My uneasiness in the situation was incredible. I started off thinking I was communicating with half a man, but after ten minutes you have to realize that a man is a soul, a brain and a heart and that was all there, so I was dealing with a whole man with half a body."

Kane likes his portraits to make eye contact with the viewer. For this one he asked McCart to pose on the deck of the beached aircraft carrier where the movie was being shot. He wanted a monochromatic non-prettiness to go with the landing line spearing the truncated body, so he waited for a glaring, hazy day and took McCart squinting in the sun. "I hope it's unnerving for the reader to be confronted by that pair of eyes," Kane says. "I want it to be a condemnation, like saying, 'Let's cool it, everybody, this happened in Vietnam. Let's not do it again.'"

The message of Cream (pages 22–23, top) another group in the *Life* rock essay, presented no problems. They simply liked to play the blues. To Kane, that meant the melancholy of railroad tracks (with perspective compressed sharply by a 28mm lens) and a setting sun inflaming drummer Ginger Baker's red hair.

But Frank Zappa and the Mothers of Invention presented him with another problem entirely. Their sarcastic, contemptuous music unnerved him, other people's photos made them look like Hell's Angels, and in short, "They scared the shit out of me." His fear abated when he met the group and discovered not hostility but warmth and a respect for the human potential; the angry

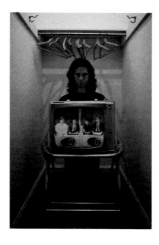

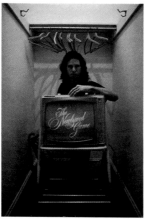

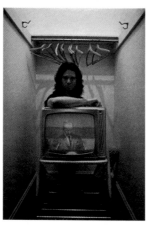

music was an attempt to shock the world into understanding. He discovered that a number of the Mothers of Invention were fathers, family men guided more by love than by hate. A solution became obvious.

Kane told Zappa, "I'm going to do individual portraits of each of you snarling and screaming, then blow them up to poster size and mount them on sticks so I can photograph you picketing the heads of state in front of the White House, demanding change."

Zappa's reaction: "Man, that's just about the worst idea I've ever heard of in my *entire* life." The message, he proceeded to explain, was humanistic and meant to shake up the *people,* who would then shake up the heads of state. A second solution appeared (pages 22–23, bottom): Reveal the Mothers as a gentle family, a totem pole of human emotion. Kane massed fathers and children tightly with the 28mm lens to make them create their own environment, contrasting naked, vulnerable babies with tough-looking men, forcing a viewer to see as he had seen—beyond the façade, beyond apparent hardness to gentleness.

So far he had been able to use natural light, with its attendant sheen, in all these pictures. But for the late Jim Morrison, prophet of doom with the Doors, he went inside. Kane had heard Morrison singing in songs like "The End" of decay, decline and fall brought on by the creeping paralysis of television and other forms of sloth. As he walked down a corridor of the hotel in Beverly Hills, California, where he was to meet the Doors, Kane was already studying the place as a possible environ-

ment for the portrait. When he entered his room he knew he had found it.

Opening a closet door, he saw a lifeless chamber, evoking the day of doom Morrison predicted. It looked to Kane as if everyone had taken his possessions and fled. Kane's assistant replaced the bulb in the closet with a 500-watt photoflood corrected for the Type A Kodachrome he planned to use. When Morrison came in, Kane added one more element, a television set to cover the singer's chest, suggesting an X-ray image of his nerve center. Shooting with a 55mm lens at 1/30 and 1/15 second to synchronize the shutter with the TV's electron gun, Kane asked the cooperative Morrison to change channels at random. "That's it! That's it!" Kane exclaimed over and over as Morrison tuned in images of a game show, commercials, Lyndon Johnson, Marilyn Monroe. . . . At the end of an hour's shooting, they were both in ecstasy over the number of hits they had made.

It was a far cry from another scene in Los Angeles two years earlier. Kane was stalking one of his heroes, Bob Dylan, around a rooftop above the Sunset Strip, trying for a portrait for *McCall's,* and Dylan—stoned and camera-shy—kept ducking behind his friends. Dylan liked the pictures Kane had shown him enough to tolerate his presence, but remained wary of anybody shooting for an establishment magazine.

"Come on, please tell your guys to go," Kane pleaded with him. "I want you to help me out." Dylan kept saluting him as a way of saying aye-aye, sir, up yours, captain. Kane thought briefly of using some of

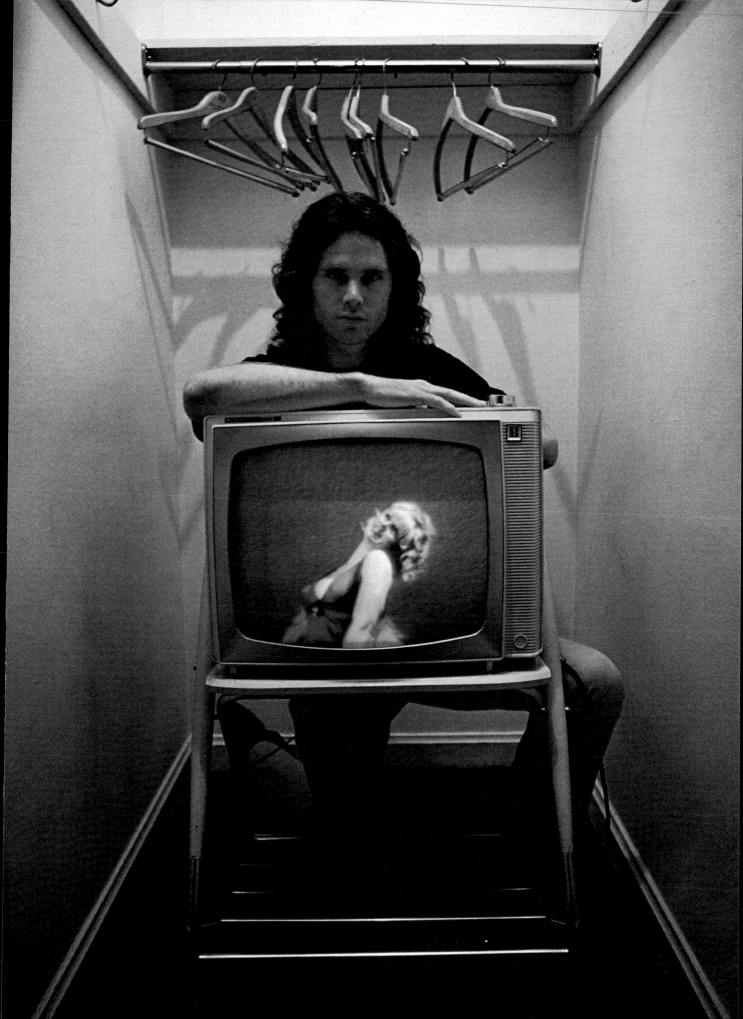

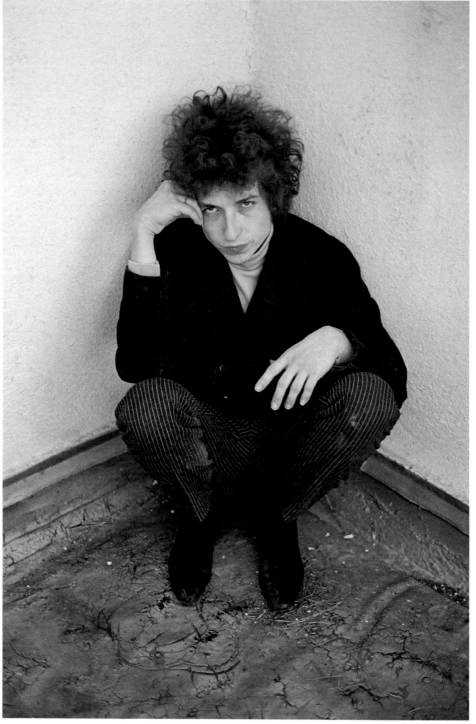

the saluting shots, but he knew they would represent a Dylan more harsh than the one he considers to be ''one of the great lyric poets of our time.'' The sun was disappearing. Kane had just separated from his first wife and was due to meet his sons in Aspen the following day to begin an Easter vacation with them, but he could see the reunion fading along with the picture.

''I'm going to stay until I get what I want,'' he started saying, ''and the longer you give me a hard time, the longer it's going to take. I want to see my kids tomorrow, but every obstacle you put up takes away from the time I have with them. I really need to be with them . . .'' and as he talked he saw tears glisten in Dylan's eyes. Dylan was touched, but he continued to evade the camera—until Kane, still talking, maneuvered him into a corner from which Dylan saw with one wild glance he could not escape. He slid down and looked up, caged. The picture at left took only a few seconds. A 35mm lens that Kane had held ready for three days caught the angle of the corner, the Kodachrome II he loved to use soaked up the soft mauve evening shadows.

''Okay,'' Dylan seems to say to the photographer, ''this time you got me.''

Bob Dylan.

Popular Culture: Interpreting With Symbols

When Kane moves from portraying a person to illustrating that person's product—a song, a story, a life in art—he intensifies the effort to organize all his thoughts about it into one statement. Flags, train tracks and TV sets can add information to a face in a portrait. But when the content of a photograph is an idea that has entered the popular culture, the use of symbols really comes into its own.

Leaning across a gap of at least two generations to understand and interpret a Dylan song such as "Subterranean Homesick Blues" (right), Kane is never ashamed to go straight for an obvious image if that is what will make a statement linger with a

Hands stripped into a manhole picture carry the message of "Subterranean Homesick Blues."

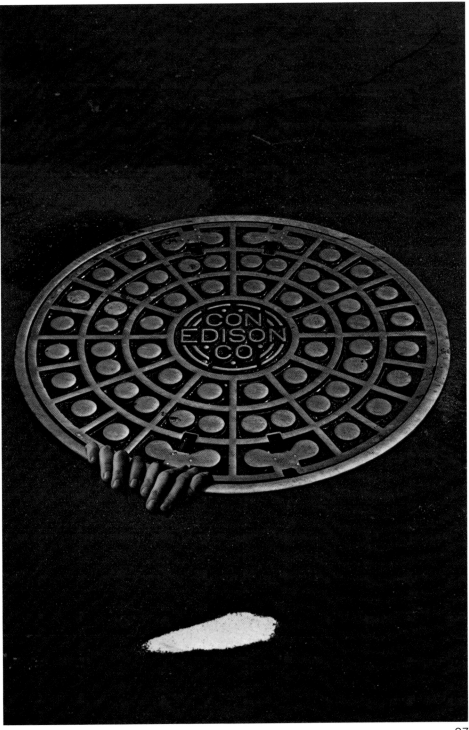

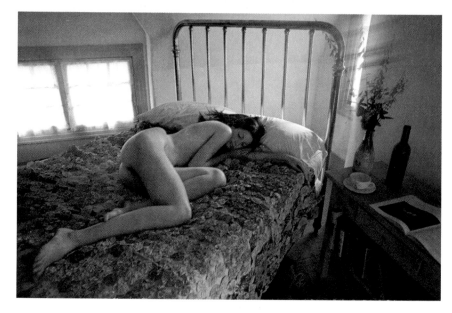

viewer. He heard the
song as a suggestion that
we all go underground to
escape a corporate struc-
ture that crushes people.
To Kane in New York,
the epitome of big mo-
nopoly was the Consoli-
dated Edison Company.
Underground plus Con
Edison meant just one
thing: a manhole. Kane
decided on a picture sug-
gesting that the homesick
undergrounder had tried
to take one quick look
above ground and that
300 pounds of American
corporate iron had
crushed his fingers.

It would be a ''one
shot.'' The model would
crawl into a manhole, the
cover would be slipped
over, leaving a safe space
for the fingers, and the
image would be recorded
on a single exposure. No
such luck. After scouring
New York, Kane found
that nobody with a man-
hole—Con Edison, the
phone company, the
water and steam compa-
nies—would open one for
a picture. Too dangerous.
Somebody had once
been really crushed.

So Kane did the next
best thing, which as it
turned out makes a pic-
ture more startling than
his original intention. He
went out early one morn-
ing and shot a manhole
cover in the street with a
55mm lens, subduing the
background by exposing

*Wide-angle lenses (21mm,
21mm and 28mm, top to
bottom) helped Kane inter-
pret three Dylan songs.*

for the gleam of metal and a patch of snow. In the studio he made another photo of his assistant's hands reaching over a curved piece of cardboard. A color retoucher put the two images together.

The picture, one of Kane's many attempts to transcend photographic realism, was shot for *Look* as part of a series illustrating Dylan songs; after *Look* folded, *Esquire* published the illustrations. Until he teamed up in the late 1950s with Allen Hurlburt, *Look*'s art director, photographs had seldom been used to illustrate cultural themes. One deadly aspect of photography in that context is its literalness. "If you just take a straight picture of what's there it destroys the mystery, the magic," Kane agreed with Hurlburt, "and that's why magazines always used paintings with short stories." About as interpretive as a photograph ever got was to illustrate "Photocrime." With support from Hurlburt and his successor, William Hopkins—who commissioned these recent Dylan photographs—Kane began early to challenge the realistic aspects of the medium.

"Dylan may look at my ideas about his songs and say I'm out of my mind," Kane says. "Regardless, they're my own observations of what I hear him say." The sym-

bols can be so simple as to be simplistic. "So what? I'm not trying to be clever, just effective."

Dylan's "Lay Lady Lay" drew from Kane a faithful rendition of what the song said: ". . . lay across my big brass bed" (bottom left and pages 4–5). He decided to be obvious "because that's just what Dylan was doing in an album of love songs, just a simple testimonial to good living and being nice to somebody you love."

But obvious does not necessarily mean literal. The lambent, mythic feel of the picture invites involvement through fantasy: That's not really the way a room looks, except in dreams . . . what will she be like when she wakes up?

Although he likes to say he does not remember much about technique—"My assistants know all that stuff, why should I?"—Kane controlled every square inch of this picture. As soon as he heard Dylan's song, he knew in his mind the tranquil, secure mood he wanted to produce. The

bed was an obvious element. But how to make it more than just another bed? Kane realized that he had for some time been studying the light in an attic room of his country house. He knew the late afternoon sun would pop through one window, and cross light would come through the other. He had the walls painted, hired a stylist to prop the room—bringing in bed, spread, table, bottles, flowers, books, shoes, everything—and asked a model friend, Jane Lee Salmons, to pose.

They shot for several hours, trying dozens of different positions and arrangements of furniture. Kane did not want to use a super-wide-angle lens because this was not the kind of picture he wanted to overpower with distortion. Thanks to the peculiarly sharp angling of three walls in the attic corner, he could wrap them around the bed with a 28mm lens—which he abused at one point to add a dreamlike streak of light across the upper right window. Wiping a little oil from his nose, he swished it across part of the lens and checked the effect through the Nikon's viewfinder; didn't like what he saw; wiped the lens with a towel; tried another swipe of nose oil. Perfect. To this day he calls the place his Dylan room, and keeps a picture of the singer up

there.

He did distort Wall Street with a 21mm lens for "Blowin' in the Wind" (middle left). To convey Dylan's point that contamination has already gone too far to stop, Kane hired a special-effects crew to set off a smoke bomb and booked several models to walk through the mess with attaché cases to depict the end of The System.

But when he heard "Who Killed Davey Moore?" he had to stop and look more carefully for his symbol. Dylan was condemning exploitation—of blacks by whites, of singers by agents, of Us by Them—and used the death of a boxer to spell it out. Kane mulled it over. Manager and crowd deny responsibility; we kill our Davey Moores; somehow Davey Moore transcends it all. What does a picture of a dead boxer look like? Very much like one of a knocked-out boxer. Nothing. But what about a crucified boxer? Yes, he thought, I'll create a resurrection. Lighting this still life with electronic flash in a boxing arena to make a halo of the shadow under the model's head, Kane tested several films before settling on Anscochrome instead of his favored Kodachrome; he wanted bizarre tones, including the reddish skin. Then he was ready for the major effect. From

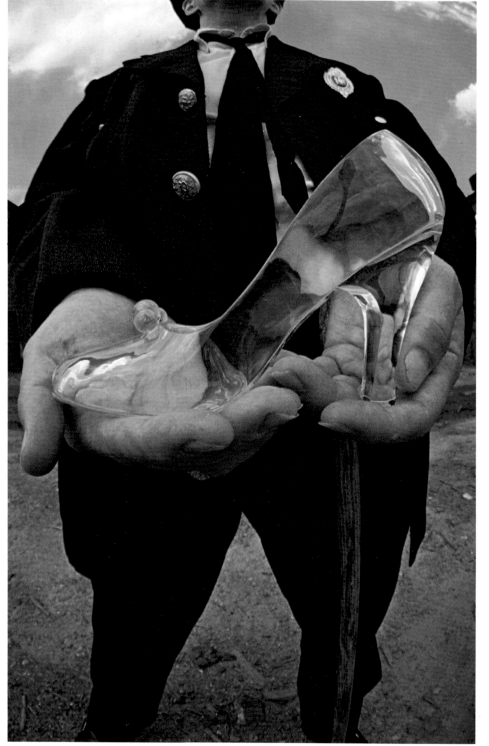

previous experience he knew that shooting wide-angle (21mm in this case) from certain positions, spreading arms, then inverting the finished picture, would produce a feeling of flight (page 28)and pages 6–7).

The lucite slipper from his "Desolation Row" illustration sits among other mementoes at home. He had it made by a sculptor, "at incredible cost," to conjure with Dylan's references in the song to Cinderella sweeping up on Desolation Row and to the "blind commissioner"—whom Kane sees as a corrupt cop, symbol of all upper-echelon seducers. "I'm dealing with a distortion to begin with," he told the model holding out the slipper, explaining what was about to happen. "Dylan's a poet screaming that Prince Charming is a schmuck and we Cinderellas shouldn't take the slipper. I'm going to cut off your face to generalize; you're all blind commis-

18mm wide-angle (left, for "Desolation Row") and subtle montage (right, for "With God on Our Side") provide two ways to generalize from specific situations.

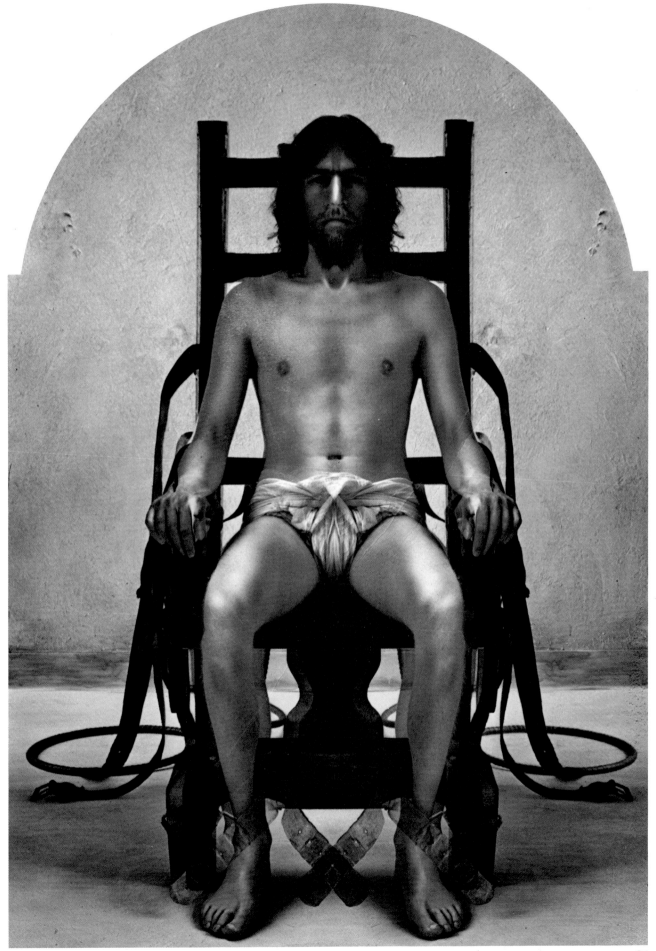

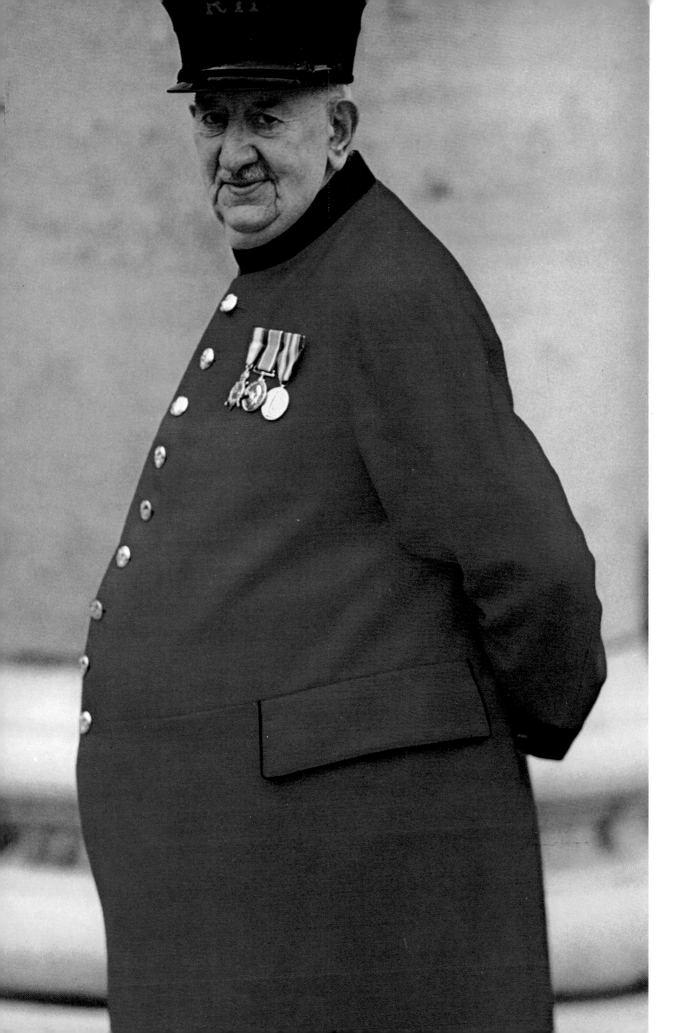

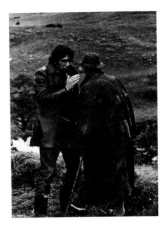

Making a TV commercial in Scotland.

sioners, not one in particular.'' He used the extreme curvature of an 18mm lens to bloat the hands and belly. ''This has to be really greedy and grotesque.''

Not only that. Kane became known for his wide-angle distortions and for his scalpel-edged delicacy with another device—montage—because he never uses them just to shock. ''I want to camouflage identities so you're dealing with symbols and ideas and not with personalities.''

He did not realize he was going to montage the illustration for ''With God On Our Side.'' Again, Kane felt a modern crucifixion would be the symbol for Dylan's bitter comment on American wars. Since he was not allowed to shoot in Sing Sing's electrocution chamber he had it duplicated in his studio; then he persuaded *Look* to fly one of his ex-assistants over from London because he couldn't find anyone in New York who looked as much like the Flemish concept of Jesus—''which is the concept I groove on.'' After all that effort, he took the picture.

''What a failure!'' he said, looking at the transparencies several days later. ''A real testimonial to my belief that you can't just shoot it like it is when you're illustrat-

Selective focus with a telephoto lens for the Beatles' ''When I'm 64.''

ing ideas. This looks like Malcolm dressed up as Jesus Christ sitting in an electric chair.''

So he had an **extra transparency made,** flopped it left-to-right over its original and sandwiched the two (page 31). ''Now everything repeats itself, it's like a Rorschach test, that's why there's a highlight down his nose, everything is super equally distributed and is therefore super-real. It

takes off the curse of literally seeing a man and makes it become ritual. This is a symbol, not a picture of Christ being electrocuted.''

Kane did not invent sandwiching, but he did refine it. Photographic montage has been used for over a century; arty photographers of the 1930s and 1940s liked superimposing different elements such as a closeup of a face and a long shot of a figure running away. ''Which I always found extremely corny,'' Kane says. His breakthrough was to merge *similar* images so that the technique is barely discernible. He will spend hours over a light table with tweezers and tape (see technical section) trying to ''marry images that belong together. Some-

where in the computer side of your brain,'' he says, ''you know as you're shooting that you're creating certain possible marriages. You don't just stick two things together.''

Nor does he fall back on sandwiching when he doesn't need it. Several years before he did the Dylan songs, *Life* asked him to interpret the Beatles' lyrics, and after listening to their records for most of a summer he flew to London.

Why didn't he stay in America and translate them into an American experience for American audiences? ''Because the

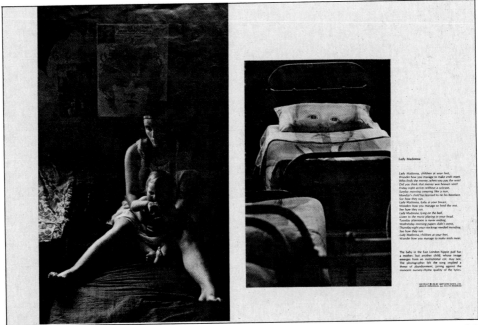

Lady Madonna

Lady Madonna, children at your feet,
Wonder how you manage to make ends meet.
Who finds the money, when you pay the rent?
Did you think that money was heaven sent?
Friday night arrives without a suitcase,
Sunday morning creeping like a nun,
Monday's child has learned to tie his bootlace.
See how they run.
Lady Madonna, baby at your breast,
Wonders how you manage to feed the rest.
See how they run.
Lady Madonna, lying on the bed,
Listen to the music playing in your head.
Tuesday afternoon is never ending,
Wednesday morning papers didn't come,
Thursday night your stocking needed mending.
See how they run.
Lady Madonna, children at your feet,
Wonder how you manage to make ends meet.

The baby in the East London hippie pad has a mother, but another child, whose image emerges from an institutional cot, may not. The photographer felt the song implied a threat of abandonment, jarring against the innocent nursery-rhyme quality of the lyrics.

Beatles' images are intrinsically English. Part of their Establishment is totally unlike ours. It's an older nation with a pomp and circumstance, for instance, that doesn't exist in the United States.'' He found in the Chelsea pensioner at left an example of pomp that really works. ''An old vet in England goes down with dignity. On Sunday he puts on his uniform with his medals for valor and he feels like a hero again. Not just hanging around in front of Macy's selling pencils.'' For once, the man's expression means as much as the picture's design. Kane simply backed off with a 180mm lens and knew he had the illustration for ''When I'm 64.''

He made the left-hand pictures for ''Lady Madonna,'' ''Eleanor Rigby'' and ''A Day in the Life'' on these pages as straight photographs, painstakingly set up. The picture to the right of each is a sandwich, as are both illustrations for ''A Day in the Life'' and the one for ''Strawberry Fields'' at right. For that one he asked the children to run up and down a field while an assistant held foliage close to his 180mm lens to diffuse the image; later he sandwiched in some very faint flowers, using one of the collection of transparencies he has made at odd times with just such possibilities in mind.

Even as the song called for grownups to cast off inhibition and intellect and regain the freedoms of childhood, Kane knew Strawberry Fields was the name of an orphanage where Beatle John Lennon had lived. The Lennon-McCartney songs he chose to illustrate speak of loneliness and pathos, and Kane responded. Al-

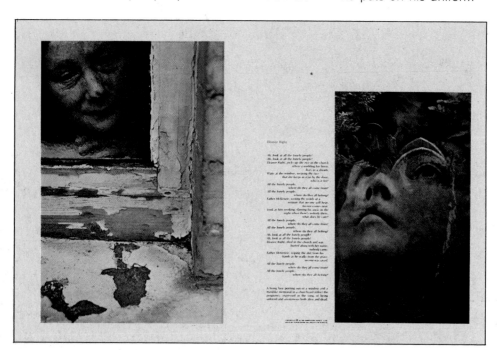

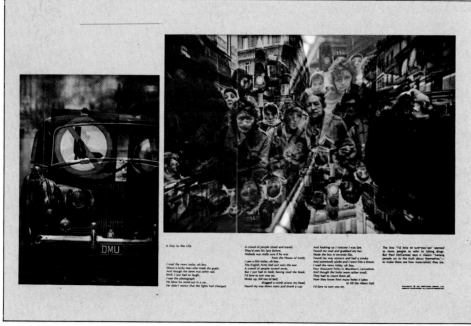

A sandwich using flowers from Kane's special-effects file speaks softly of ''Strawberry Fields.''

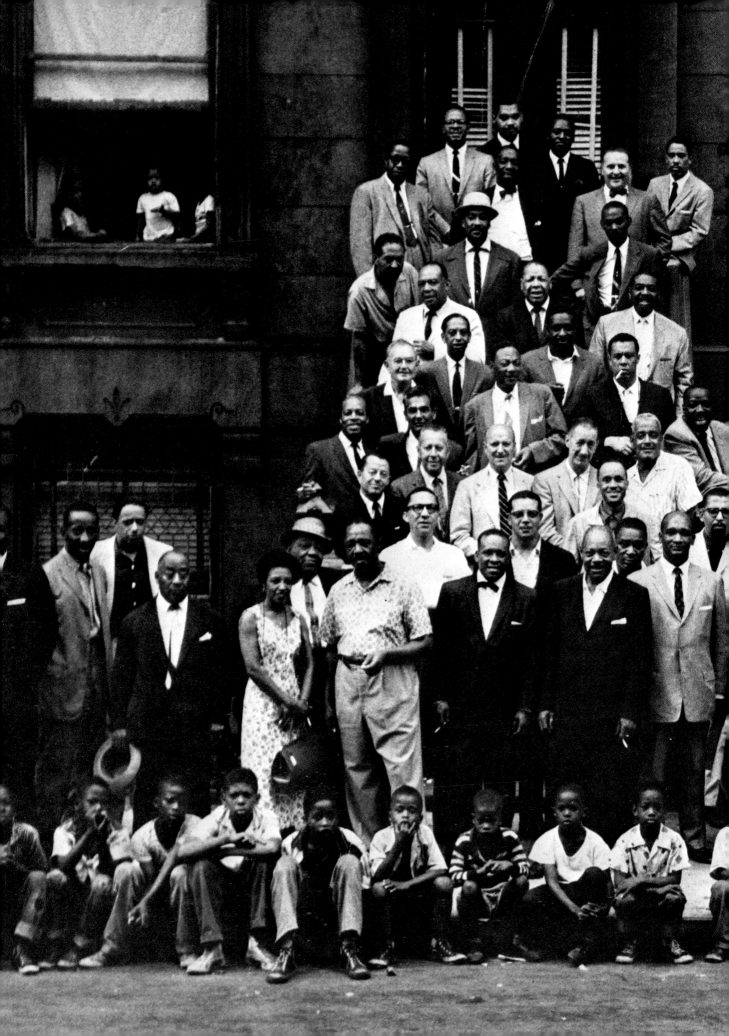

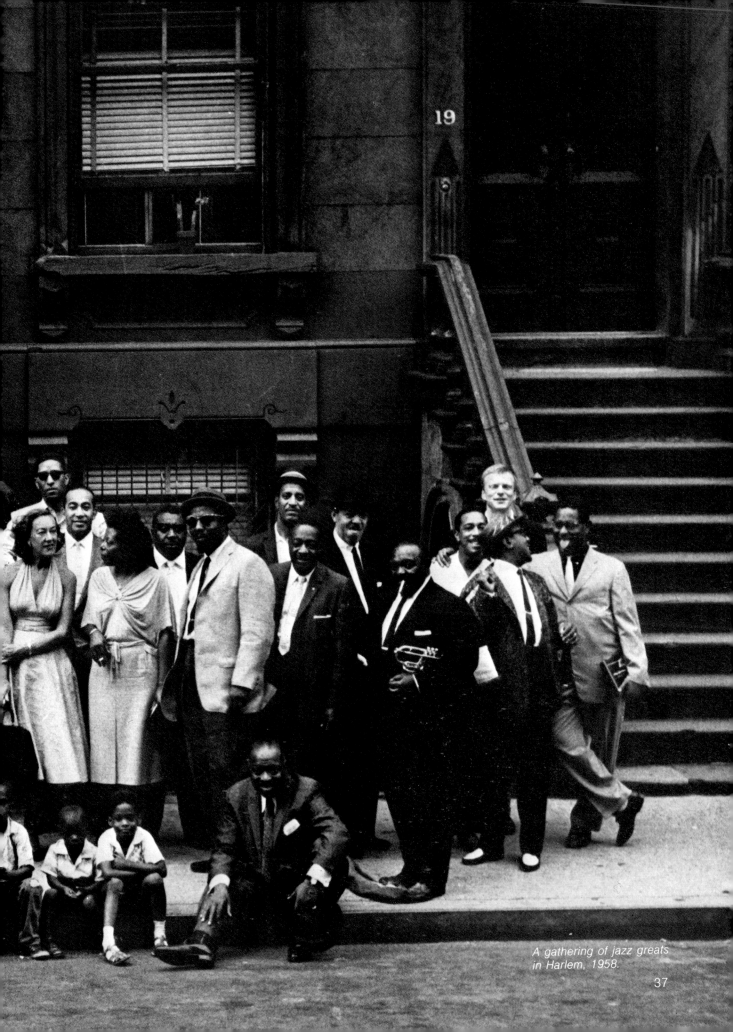

A gathering of jazz greats
in Harlem, 1958.

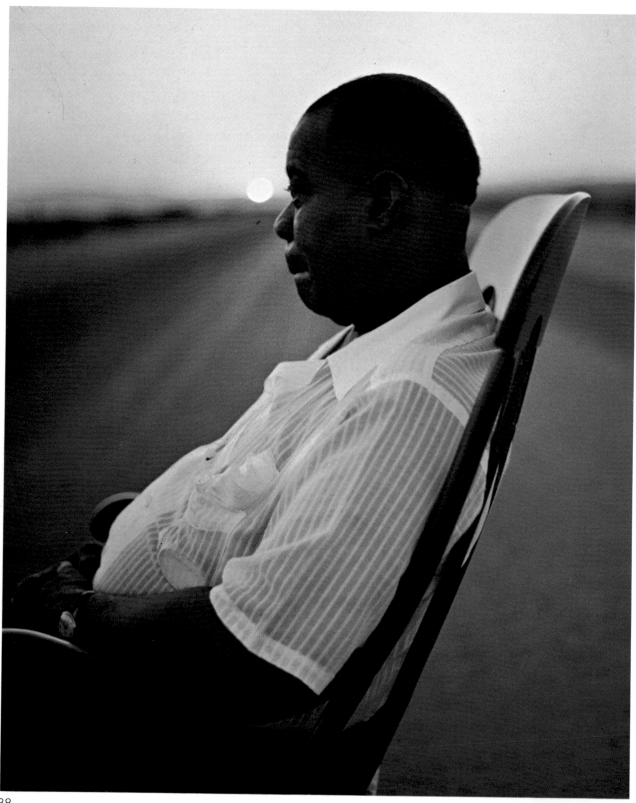

though he had attentive parents and always felt loved as a child, "I didn't really belong to the environment. I ran away from the Bronx because it was a stifling, narrow-minded, fearful kind of community. Life is downtown, man, not uptown. Nothing but immobility uptown. Downtown is action and yellow-haired beauties."

If that sounds like an out-and-out pursuit of pleasure, it is, and it helps. The "Lady Madonna" montage (page 33, repeated on page 72) combines the symbol of an empty Salvation Army bed with the face of an orphan. The child could have been photographed anywhere, yet Kane insisted on finding an orphanage near London.

"One of the joys of my work is that it forces me to move in and out of places I would never see ordinarily. The Beatles' songs are universal. I guess I could have shot them in a studio. But if you're going to put eight or twenty hours a day into what you're doing, you might as well enjoy it. I never went into photography as a means of making a living. I was a commercial designer and photography just happened. . . . Going to England, to that orphanage, is one of a thousand such experiences that give color and scope to my life. And they ultimately reflect in the work itself."

Louis Armstrong: the picture that changed Art Kane's life.

E motion into Images

Lester Young, reflected.

Mr. and Mrs. Louis Armstrong, a trumpet, an antique chair and Art Kane met the pilot of a four-seat Beechcraft at the Las Vegas airport late one afternoon in the summer of 1958. They were there because of an idea that had struck Kane several weeks before. He was going to fly the great trumpeter away from the bright lights to a sunset on a deserted stretch of road in the Mojave Desert and return in time for Armstrong's eight o'clock show.

It soon became clear that there was one person, or thing, too many for the airplane. The chair Kane had bought that afternoon was more important than Lucille Armstrong that day. She had to stay behind while it occupied the fourth seat. The airplane took off. Kane barely had time to recall that a few days before he had been at his drawing board at the Irving Serwer agency, sketching fashion layouts, when outside the tiny aircraft a sinking sun struck waves of color into clouds layered like a mountain on fire, and Louis Armstrong picked up his horn and began to blow. He erased the drone of the engine with "Old Rocking Chair," the tune that had given Kane the idea for the picture they were on their way to make.

"It was like going to heaven with Gabriel,"

Kane later told Bob Benton, the art director who had just replaced Henry Wolf at *Esquire* and sent him on the job. "That horn . . . I realized, my God, I can't go back to a drawing board . . . What an experience. This is the way I want to live from here on in."

The airplane landed and Kane realized he had only a few minutes before sunset. He plunked the chair down in the road. Armstrong sat in it, picked up his horn again and turned to face Kane.

"No, Louis," Kane told him. "Put the horn down." He was tired of seeing pictures of Louis Armstrong with sweat all over his forehead and cheeks puffed out, Kane had told Benton. He's getting older, we

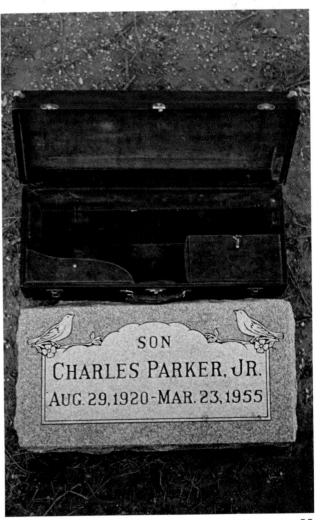

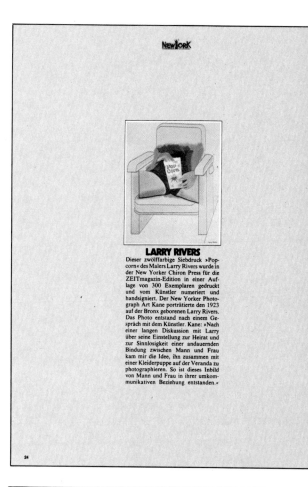

shouldn't make those demands on him any more, he's going to blow himself to death. "You can cool it now, Louis," he said to his subject. "You deserve it."

"All right, man," Armstrong said. "You're the artist," and he folded his hands in his lap.

It was a moment that changed Kane's life. "Right then," he says, "I realized the intense joy of having an idea, based on research and some understanding of my subject, conceived 2,000 miles away and seeing it start to happen. Louis Armstrong was in a rocking chair at late light."

If Kane were to be blamed for pioneering a few visual clichés, one would be the sun ball and another would be the wide angle that came later. He and Bert Stern (see *The Photo Illustration,* Masters of Contemporary Photography), among others, found late light to be soft, romantic, poetic.

"The sunset of Louis Armstrong's life," he later said with a little shrug as he showed Benton the picture. "How corny can you get? But when it's right, it's right."

This was Kane's first interpretive portrait. When Benton had asked him to portray the world's leading jazz musicians, he was still dabbling in photography and owned only a couple of

40

cameras—a Hasselblad and a Contax D, an early single-lens reflex. He was more comfortable with the Hasselblad, having started out with 2¼x2¼, so he used it and its normal 80mm lens for Armstrong, designing the picture as a vertical despite the square frame, and shooting on Ektachrome for speed he could not get from the Kodachrome (ASA 8) of the day.

He did use the Contax a few days later for the only portrait he could make of another jazz great. Charlie "Bird" Parker was dead, so Kane's idea was to suggest that Parker's spirit had ascended along with his instrument by photographing an empty saxophone case next to the grave marker—if he could find it. Detective work around Kansas City led him on a mercifully overcast day to a tiny cemetery where the caretaker said, "Never heard of him. Look around." Kane finally stumbled on a disappointingly flat little stone. Then he realized that the dimensions of the stone and the sax case were identical. "Suddenly I was standing all alone over this grave outside Kansas City with goose bumps all over me. Weird."

Back in New York, *Esquire* was collecting every jazz musician they could get their hands on for a black-and-white opening spread (pages 36–37). Kane gathered them on a Harlem street with a few neighborhood children and started trying to get all eyes to look into the camera. The police had blocked off traffic, but quieting down 56 free spirits at a reunion was rough. Kane rolled up a *New York Times* into a megaphone, retreated across the

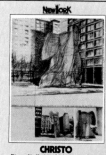

LARRY RIVERS

Dieser zwölffarbige Siebdruck »Popcorn« des Malers Larry Rivers wurde in der New Yorker Chiron Press für die ZEITmagazin-Edition in einer Auflage von 300 Exemplaren gedruckt und vom Künstler numeriert und handsigniert. Der New Yorker Photograph Art Kane porträtierte den 1923 auf der Bronx geborenen Larry Rivers. Das Photo entstand nach einem Gespräch mit dem Künstler. Kane: »Nach einer langen Diskussion mit Larry über seine Einstellung zur Heirat und zur Sinnlosigkeit einer andauernden Bindung zwischen Mann und Frau kam mir die Idee, ihn zusammen mit einer Kleiderpuppe auf der Veranda zu photographieren. So ist dieses Inbild von Mann und Frau in ihrer umkommunikativen Beziehung entstanden.«

CHRISTO

Dieser fünffarbige Lichtdruck mit zwei handcollagierten Photo-Elementen »Wrapped Sylvette« wurde bei Domberger in Stuttgart in 300 Exemplaren gedruckt und vom Künstler numeriert und handsigniert. Das Werk ist Bestandteil eines Projektplanung für die Verhüllung von Picassos Statue »Sylvette« in New York. Auch mit dem 1935 in Bulgarien geborenen Christo, der schon die Felsenküste bei Sydney »verpackt« und einen amerikanischen Canyon durch einen Riesenvorhang geteilt hat, unterhielt sich Photograph Art Kane lange, bevor er ihn porträtierte: »Christo erzählte, er denke sehr über die Faszination der Vergänglichkeit nach; darum seien auch seine monumentalen Werke sämtlich aus zerbrechlichem, hinfälligem Material; seine Riesenvorhänge beispielsweise seien verwundbar den Elementen ausgesetzt. Ich habe Christo in einer Phase der Entmaterialisierung photographiert — er ist flüchtig, wie sein Werk.«

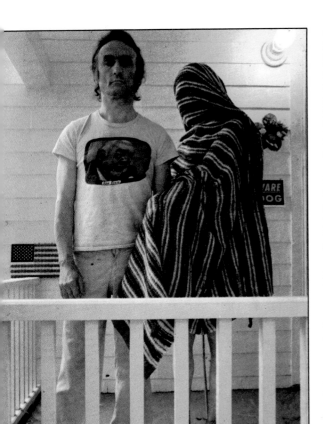

street with his Hasselblad, and started bellowing, "Okay, guys, look over here, let's get it over with, let's do it and go home. . . ." For the third time in two weeks he felt a surge of power as he saw his idea come alive.

"I'm no expert at handling crowds," he says today. "You just have to do a lot of yelling, assert yourself, or they'll overwhelm you and you'll be at it forever."

Lester Young, a man so bitter that Kane portrayed him in a distorting mirror (page 39, top), hated the crowd shot. "If you had a bunch of white musicians, man," he told Kane during their private shooting a few days later, "you'd have done it on Park Avenue with a limousine to bring every one of them. And you wouldn't have had no pickaninny kids."

Kane said, "What are you talking about? I wanted it to be a kind of alumni shot of great jazz people in the place where they brought jazz to New York originally, which is Harlem, and those kids may represent pickaninnies to you, but to me they represent a kind of third generation, maybe the future."

"There's no future for those dirty-looking pickaninnies," Young said. He died a short time after.

The jazz pictures won Kane his first New York Art Directors' Club gold medal for photography, possibly because his feeling for music, an emotional medium, had leaped into his designs.

But the interpretive approach to cultural forces does not stop at music. In 1974, *Zeit* magazine in Germany asked Kane for portraits of five artists representing the so-called "New York School," and presented him with an interesting

challenge: Two were in Europe, where he didn't have time to go. Of those available in New York, Kane knew Larry Rivers slightly, so after some homework in bookstores and galleries he drove to Rivers' house on Long Island to talk and develop a concept. The first thing he saw was a ghostlike woman, shrouded like a Moslem, standing quite still on the porch. Even after it turned out to be a mani-kin, Kane could see why it had upset the neighbors. He and Rivers spent much of their time talking about their divorces and Rivers' disillusionment with any kind of permanent male-female relationship. (Kane, nearly five years after his second divorce, had fallen in love and felt better.) He decided the portrait would show Rivers feeling the only woman he could live with, the store dummy.

Christo Javacheff wraps and unwraps things like buildings and the cliffs of Dover, and undertakes huge, destructible projects such as a nylon curtain across Rifle Gap, Colorado, because—Kane decided—"he's fascinated by the idea that nothing lasts." To portray a man interested in life-death cycles, Kane made him vanish from the roof of his loft by simply overexposing one extra stop for each shot.

As for the absent artists, he decided to work with snapshots provided by *Zeit*. Walking by a newsstand on the morning of October 4, he slipped a picture of Cy Twombly and his friend Robert Rauschenberg under the string of a stack of the *New York Times* (next page), in the spot where a lead picture might appear. A clear enough way to say "New York Artist."

41

"All the News
That's Fit to Print"

The New

VOL. CXXIV No. 42,623

NEW Y

MRS. FORD RECOVERING RAPIDLY: Betty Ford and the President finding a message from her
visited her at hospital Wednesday evening. Her recovery is faster than had been expected. Page 1

F.D.I.C. REJECTS FRANKLIN'S PLAN

Decision Appears to All but
Assure End of Troubled
Bank in Present Form

Assure End of Troubled
Bank in Present Form

Bank in Present Form

Assure End of Troubled
Bank in Present Form

Decision Appears to All but
Assure End of Troubled
Bank in Present Form

Iran and U.S. Banks Lend Grumman $200-Million

By RICHARD WITKIN

A $200-million Iranian and Navy $35-million, for allowing
package from a group of Amer- Navy payments for the spring
ican banks and a state-owned wing F-14's. The Navy had
Iranian bank yesterday re- sought Senate permission to in-
solved the deep financial crease the loan to $100-million,
troubles that have been threat- but the Senate refused by a
Iranian bank yesterday re-
solved the deep financial crease the loan to $100-million,
but the Senate refused by a
Iranian bank yesterday re-
solved the deep financial crease the loan to $100-million,
ican banks and a state-owned but the Senate refused by a
Iranian bank yesterday re- sought Senate permission to in-
solved the deep financial crease the loan to $100-million,
troubles that have been threat- but the Senate refused by a

NIXON BIDS C
QUASH SUBP

Erica Declines to
an Ex-President's
Avoid Testifying at

Avoid Testifying at

Avoid Testifying at

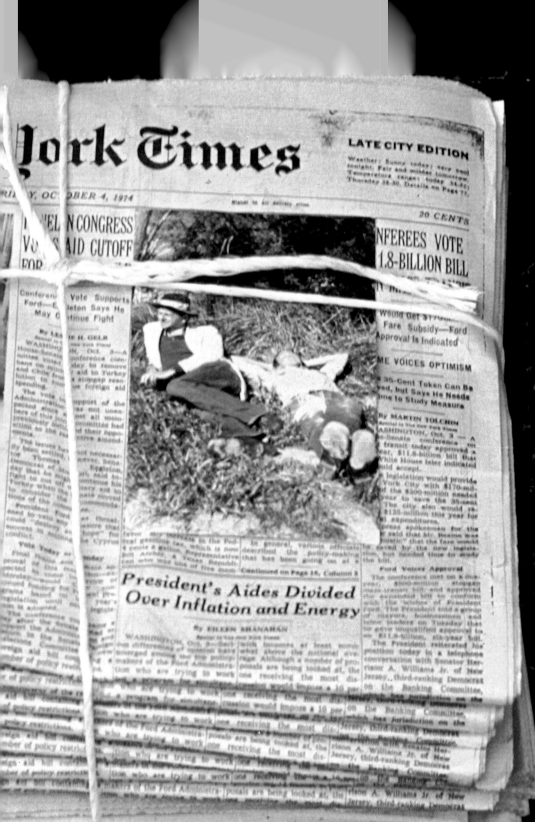

After much thought about the problem of photographing an absent artist, a clean solution.

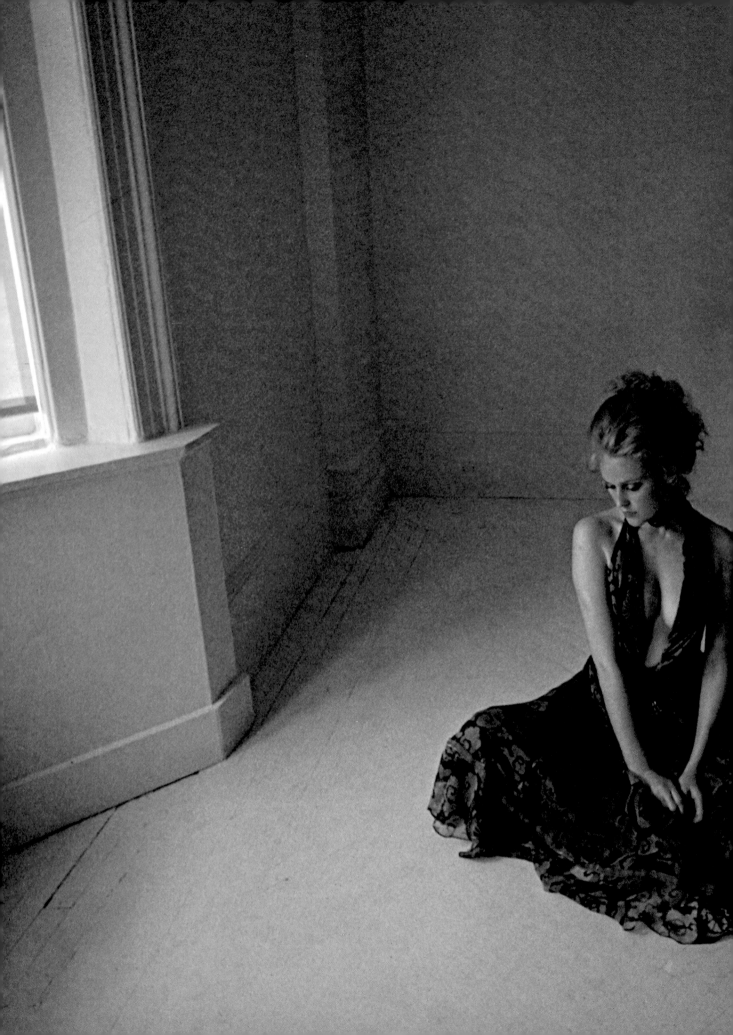

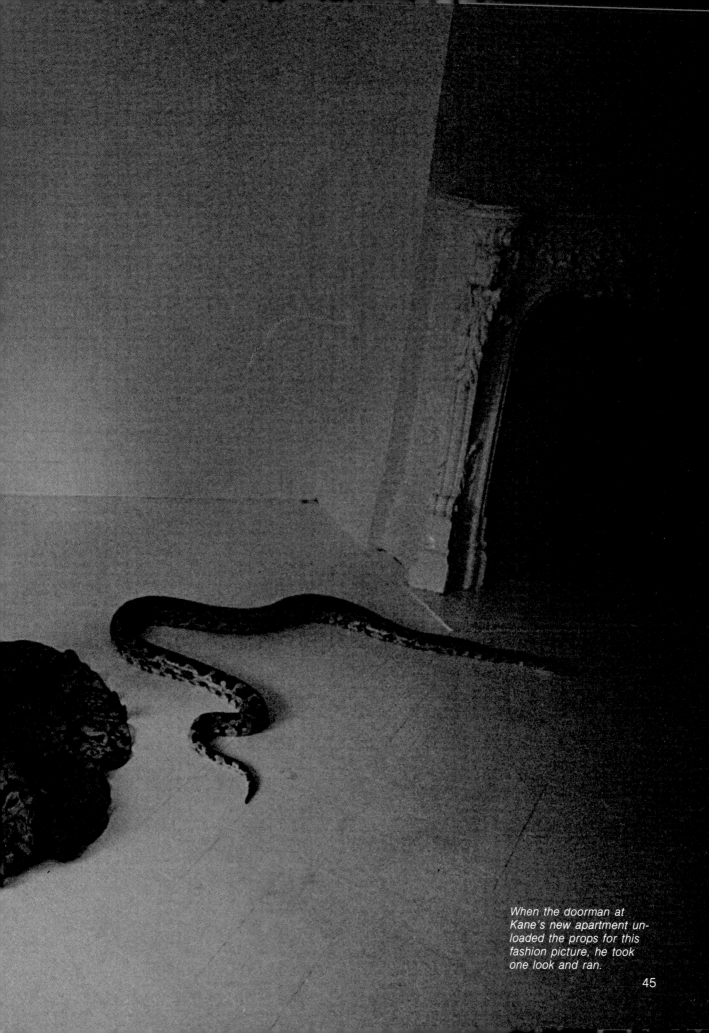

When the doorman at Kane's new apartment unloaded the props for this fashion picture, he took one look and ran.

Telling Stories: Personal Vision in Commercial Pictures

"You love your boy friend and he's left you. You're alone in a big city and an empty apartment." Kane had not yet picked up his camera, but Margrit Rammé was working on the sadness. She was also scared of the snake.

The editors of *Queen* magazine had asked for an entire issue to be called "Art Kane's New York," including fashions, and he had said all right—but don't expect to see laughing girls running down Fifth Avenue. He had just divorced his second wife, had not yet met Jean Pagliuso or photographed Larry Rivers, and felt fairly bitter.

If you want to call it Art Kane's New York, he told *Queen,* you'll have to accept pictures showing that the place right now is kind of empty for me. Righto, they said.

He left the studio and rummaged around for real-life locations. He had found the apartment on Gramercy Park, and decided to shoot the fashions there before the furniture came in. Truth is, he wasn't motivated entirely by a desire to display his mood. Not only does training as an art director make him look for a theme when he has space for an essay, as against a bunch of random shots that just present the merchandise; Art Kane loves almost more than anything else to tell a story.

He also loves snakes. The first boy scout in the Bronx to get a Reptile Study merit badge, he kept 32 of them at home despite a mother who tried to make him flush the first one down the toilet.

This story would reflect the dilemma of a lovely woman—always beautifully dressed, of course—searching for a man, for identity, for something. A snake would be not only an obvious male symbol but also a reminder of a Garden of Eden to start it

Natural light on stockings for Vogue.

off. Since Kane had given his collection to the Bronx Zoo when he was drafted, he called All-Tame Animals, a provider of non-human performers in New York. They referred him to a snake owner in one of the city's residential hotels, asking that he be discreet; she would be evicted if the management discovered that she kept a boa constrictor

and a python in her room. So Kane was Uncle Joe when he called to ask about Cousin Bea: "She must be a really big girl by now. Oh, six feet six, that sounds good." And Patricia? "Over eight feet tall? My goodness." He went over to see them. Their owner showed him the boa in her bathtub and pulled the python out of a closet. "Ter-

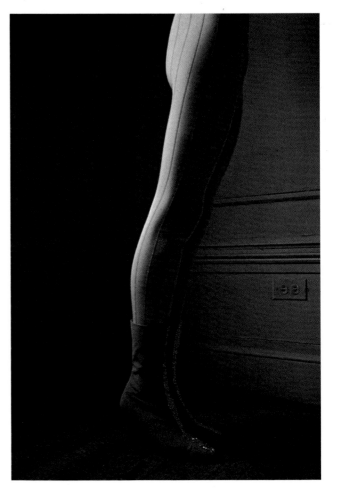

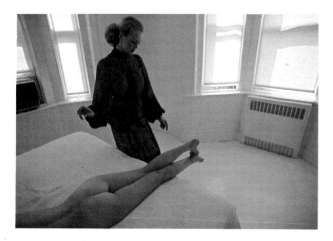

The middle photo, for Vogue, *was one of the first commercial uses of the 21mm lens and a forerunner to Kane's "flying" pictures.*

rific," he said. "Bring them up to my place at 10 o'clock tomorrow."

When she arrived with the snakes in a laundry bag, Kane was moving white window shades up and down, studying the way they filtered the natural light he would use all day. Morning light came softly through the west-facing windows of the living room. He arranged the python, then stood back to peer through a Nikon. Moving forward, back, left, right, he kept the model close to the center of the frame. He was using a 24mm lens, not only for depth of field that would keep the picture sharp from front to back but also to make objects near the edges seem to lean away, focusing attention on the center.

"Okay, Margrit, you're unhappy, unaware, the two of you can never really come together. . . ." Bracketing—one shot at a normal exposure, one above, one below—he redesigned the picture as he moved. "That's it, keep it, keep it," he told her when he liked what was happening. "Now, hold every pose for three clicks and then change . . . Beautiful. Now keep

that until I say stop. I want to explore this until we've eaten it up."

Ninety minutes later he had eaten up the male-female situation (pages 44–45) and moved to the bedroom (top left) to set up an identity problem. A second model had arrived. "You're clothed and you're naked," Kane said, "you're really the same woman, trying to figure out who you are." This time he wanted to stretch the image more alarmingly toward the edges, so he put on the 21mm lens that he had used to shock the editors of *Vogue* on his first fashion assignment.

You could trace Kane's career in photography through his affection for the different lenses that have come into his life. He discovered the medium through "normal" vision, first in the optics of his Ciroflex and then in the 80mm lens of the Hasselblad and the 50mm of the Contax D.

His next lens was a 180mm Sonnar, for which he feels more love than any other, maybe because it was the one he bought in 1959 when he realized he was committed to photography. "I grew like crazy with that lens," he says today with a soft smile of reminiscence. He could not have done it, of course, if the modern

single-lens reflex camera had not been developed in the late 1950s. The older rangefinder camera—a reporter's instrument—permitted interchanging, but not viewing through the lens itself; early SLRs, manufactured in a 35mm format as far back as the 1930s, were too cumbersome for professionals. With improvements such as the instant-return mirror, automatic diaphragm and pentaprism viewfinder, however, the new SLRs gave photographers like Kane a new way of looking at pictures.

"For the first time, the

A fleshy little turn of a leg for sex and an unexplained key for mystery brought stockings to life in Vogue.

system was really portable," he says. "You could put a long lens on your camera and actually see, as you stopped down or opened up, the exact image that would soon be on film. You could see the spaces between leaves become circles."

Under his black cloth in his private theater, he began to design with the

f/stop ring. Close it down and depth of field increases; open it up and everything but the subject goes out of focus. Looking into the naturally shallow depth of field of the 180mm lens, Kane became one of the inventors of selective-focus photography. Today, it is "like the big cliché of all time," he shrugs, but in the 1950s

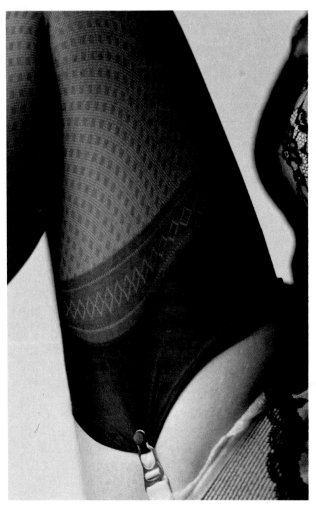

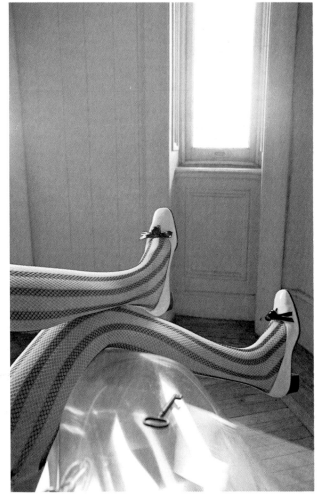

and 1960s it was everywhere. You could shoot a portrait in a Lower East Side alley and control precisely how much foreground and background the lens would transform into elegant masses of color.

Then came the wide-angles. The great depth of field of the 35mm lens took Kane to the other extreme, keeping a picture sharp from edge to edge. But it was with the 21mm that he began to invent effects that became his trademark. Most people started using the wide-angles as broad-vista recording instruments. Kane looked through the viewfinder of the Nikon he had begun using almost exclusively, saw what happened, and started using the 35mm and 21mm for closeups, fascinated by foregrounds and backgrounds appearing practically on the same plane and by the distortion of that pull to the edges.

Alexander Liberman and Diana Vreeland of *Vogue*—he the designer supreme, she the editor-in-chief from 1962 to 1971—began wooing Kane. He resisted. He had run away from fashion to become a persuasive photographer. He respected some fashion photographers, particularly Richard Avedon. But he was not so much interested in women's clothes as he was in women, and he claimed he had

no flair for dressing a woman—"although I appreciate it when she puts herself together nicely."

Vreeland cracked him with a challenge: "What are you afraid of, Kane?"

All right, he said silently, I'm going to twist it into a shape you haven't seen before. In one of the first commercial uses of the 21mm lens, he aimed it high and low at the models, never straight on, and produced a portfolio that jolted *New York Herald-Tribune* women's editor Eugenia Sheppard into reporting that the new star on the scene was "anti-fashion." A corner of the world that had been safe and smooth suddenly looked bizarre, outrageous.

One of his favorite pictures from that take (page 47, middle) was shot with the model's feet at the bottom of the frame. Kane accidentally turned the print on its side and realized that it looked as if she were flying. "There is something spiritual about this picture," he told Vreeland. "It shouldn't be, it's just a girl in a coat, but my hand in the foreground . . . it looks as if there's some communication or power, as if I'm forcing her to fly."

In that picture he discovered the wide-angle inversion that can make a subject "float" like Davey Moore on pages

6–7 and 28, the spiritual voyager on pages 94–95, or the bathing suit model below (shot on a Cornwall beach for *Harper's Bazaar*). Photograph the same subject through a lens with a focal length of 35mm or longer, turn the picture

Turn the page upside down to see how this Cornwall beach looked through Kane's wide-angle.

over, and the effect will not happen. The forced perspective of a super-wide-angle lens does the trick.

Kane still makes flying pictures, but he long ago stopped using the wide-angle to snarl at fashion. "I used it as a protest, and fashion doesn't deserve that kind of personal imposition. Sure, I'll dramatize an idea, but in fashion you're com-

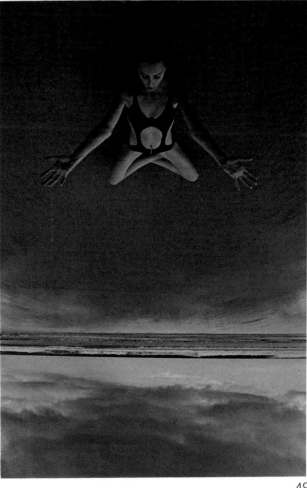

mitted to showing the clothes. If you aren't doing that, you don't belong there."

He began to combine showing the clothes with telling the stories dear to him. Why are the women in a *Vogue* feature on stockings (pages 46, 48) in empty rooms with a key beside them? Simply because Kane would rather evoke a mood that reflects what he is looking for himself—a serenity tinged with mystery—than hoke up the flamboyance one usually associates with fashion. Part of his method involves the use of natural light for striking effects: He shot the snakelike legs on page 48 straight into a window facing south, exposing for the

Pushing the limits of fashion: Showing more than the head for a hat feature, inventing a lady photographer's dilemma for a Viva *stocking story.*

stockings so that details outside would bleach away. Another part of it can involve judicious use of any lens in his family. "As each one was invented," he points out, "it influenced me. My way of seeing changed. It's as if I married each one. Now we're all living together."

More and more clients called on Kane to do his wide-angle act, and he realized that the 21mm lens was a trap. It was a sure-fire way of making something startling if not always effective. "Too many people started abusing it; there was grotesquerie everywhere you looked. I was starting to use it as a crutch, so I shelved it."

The 21mm lens was followed by development of a compact 500mm that for a while brought Kane back to selective focus. Yet he still pulls the extreme wide-angle off the shelf when he sees an intelligent use for it—in flying pictures; for Dylan's "Desolation Row"; in the elevator at the bottom of page 47, which he shot with a 15mm Konica fisheye lens designed to produce a rectangular image instead of the round one common to fisheyes; even for a few fashion shots. He used the 21mm to reinforce a sense of sorcery in the designs of Zandra Rhodes (next page). "Her clothes were weird and she would bleach hair green, that sort of thing, so I made up a story about a witch who lures children into her baby carriage with cupcakes and toys and then destroys them." A little hallucinatory distortion on the beaches of Fire Island did not keep the clothes from showing.

They show, but the stories are not about them. Kane's overriding interests lead him to deal

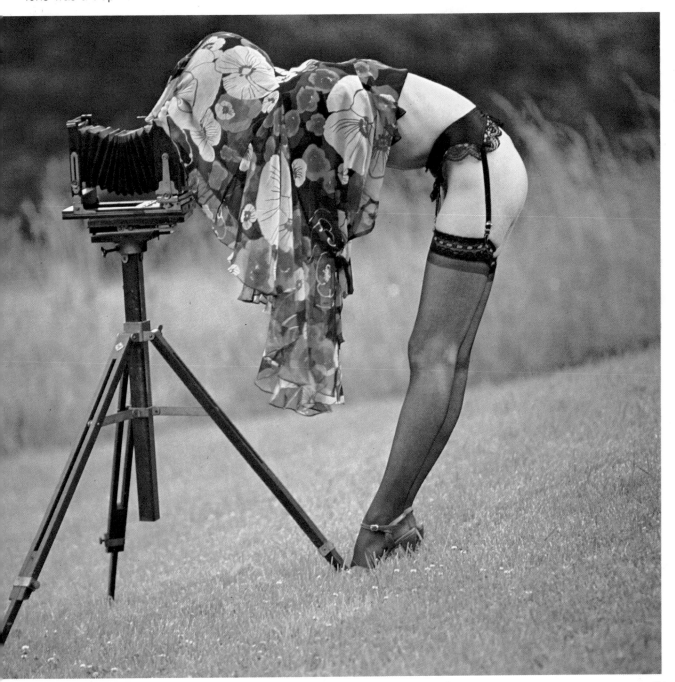

whenever possible with women wearing as little as possible—"so the clothes won't interfere with the way I feel about women, which is more of a sensual and spiritual trip."

And that leads to an episode that Kane describes as his "serious jump into the fleshpots." For one year in 1973–74 he worked as corporate design director for the publisher of two sex-oriented magazines, *Penthouse* and *Viva.* His mandate was to function as an art director in nurturing the graphic personality of the company's products, primarily its women's magazine, *Viva,* but he did

Kane summed up the spirit of these clothes with a little plot about a witch and her baby carriage.

not give up photography altogether. One challenge was to deal with fashion in a way that would "marry applied art and eroticism—well, commercial pornography—without diluting either."

How could Kane show an accessory as innocent as a hat, for instance, in a way that would challenge *Vogue* while promoting *Viva's* air of sexual audacity? He photographed not just heads but whole naked bodies during a winter visit to the West Coast, using late-afternoon sun on a ranch near Los Angeles to keep flesh tones warm (page 50).

Wanting more opalescent skin tones and more detail in shoes, stockings and garter belts for another *Viva*

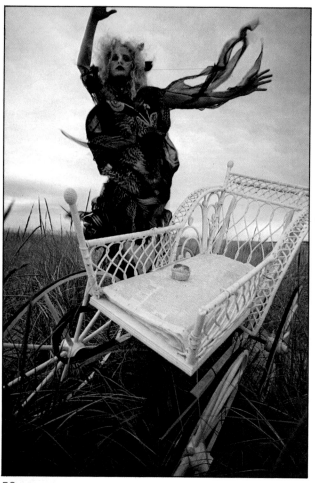

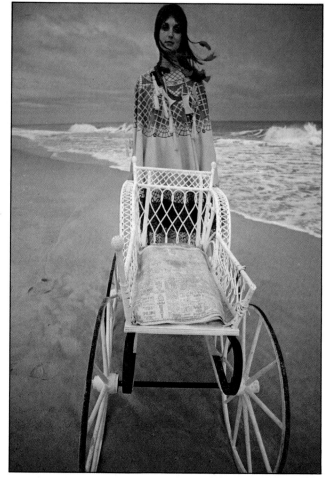

Some different hair styles for Viva.

fashion shooting, Kane picked a summer day on the East Coast that was heavily overcast (no harsh shadows). He and the model, who had been cast for the line of her legs and buttocks, drove from Manhattan to his house in the Catskills. While an assistant fussed with the props on the lawn, Kane explained the story. He remembered seeing a show on landscape photography at the Museum of Modern Art that had contained several pictures of old-timers shooting mountain vistas with 8x10 view cameras. "So what you're going to be is a lady photographer who didn't bring a black cloth to put over her

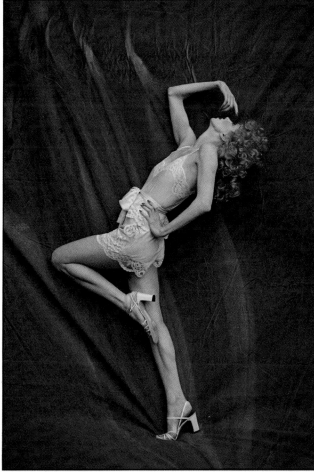

head. You'll use your dress. Believe it or not, I used to do the same thing with my jacket." Selective focus kept the picture sharp through a plane extending about a foot to either side of the model, making her stand out from the softer but still recognizable background (pages 50–51).

The location was familiar, but Kane might have chosen a number of others from his files. Like most commercial photographers, he keeps a list, accompanied in some instances by Polaroid snapshots, of places he might someday want to use in a picture. He can also draw on a mental file of photographic effects—the froth of saltwater foam on a beach, a slant of light that can make canvas look like velvet (at left). "Your total life experience will ultimately pop out, one way or another," Kane says, looking out from beside his fireplace at the snow-covered lawn that had been so green for the lady photographer. "I guess my greatest joy in the whole medium is conceiving ideas and arranging all the preliminaries that go into a picture. The execution itself is just mechanical. The ultimate joy is of course to see the idea fulfilled somehow."

If that is so, why would he give up, even for a year, the independence and six-figure income of a successful freelance career in which he had spent *all* his time conceiving ideas?

"Well, the moral structure today is tremendously changed from what it was even ten years ago, and one is able to deal with subjects—nudity, sexual behavior—that then were considered taboo. I was intrigued with the idea of entering the arena in which *Playboy, Penthouse, Viva* and others had become mass magazines, to see whether I could bridge the gap between art and pornography, whether I could deal with it on a tasteful level without diminishing the erotic aspects of it."

Early on, he was trying to think of fashion and beauty ideas for *Viva* one day while having his hair cut at the salon of Paul Mitchell, one of the new virile breed of hair stylists.

"Who needs another fashion magazine?" he asked Mitchell, rhetorically. "Why should *Viva* deal with hair the way *Vogue* and *Bazaar* do?"

"No reason," Mitchell said, pitching his English accent above the roar of a blower. "You know, Art, in an age of public nudity, we shouldn't just stop at the scalp. I could see styling arm pits and

pubes. Now, pubic hair . . . We can do arrow shapes, butterflies, centipedes, heart shapes . . . I've designed a curling iron with insulated edges so we don't burn the little thighs. Oh, absolutely, we can't burn the thighs.''

A few days later the two men and *Viva's* fashion editor held a casting session in Kane's office. In came 12 Penthouse Pets, young women who had stripped for the centerfold during the past year, some of them embarrassed for the first time in their lives. ''Come on, girls, you know what you're here for, let's get on with it, let's be professional,'' Kane said. ''Oh, all right, why don't you all go out and come in one at a time.''

The first Pet to come back in hesitated, blushed, turned to face the wall and then, barely breathing, pushed down her pants and turned back for inspection. Immediately, Mitchell moved in and dropped to his knees. ''Oh, you have a lovely pussy, my dear,'' he said. ''Mind if I touch? Now, Art, this can make a fine heart shape, right? Heidi, you're going to be our heart shape.''

''Thank you,'' she said.

''Here,'' Kane told her, ''hold this matte board in front of you so I can see the pubic hair framed the way it might be on a page.'' Making notes for

each one *(Heidi: heart. Black & blue mark inside right thigh. . . .)* he worked his way through all 12 Pets.

On the day of the shooting, Kane, Mitchell and their assistants moved purposefully through a studio full of young women stretched out on tables with legs dangling over the edges. For one of the few times in his life up to then, Kane poured artificial light on a subject—electronic flash with hardly any shadows—and then framed each picture tightly with a 55mm Micro-Nikkor lens. The noise of the motor-driven Nikon that he uses for almost everything except slow shutter speeds—''I love the feel of it and I'm never trying to sneak up on anybody''—bothered no one.

Later, he had dye-transfer prints painstakingly retouched to clean up details: making the waist perfectly even in pictures such as the one at left, removing every possible blemish. ''When you get in that tight, no matter who it is, there are going to be some skin imperfections. These pictures had to be beyond perfection to make the hairs super-real. Otherwise it would have been vulgar.''

The first time he shot a copulation series, a more or less standard feature in *Viva*, Kane wanted to change the imagery he had found so

distasteful in sex magazines. ''Those gushy, phony pictures of couples screwing on thick carpets in front of a fireplace . . .'' he shakes his head. ''I wanted to upgrade the sexual imagery without downgrading the erotic aspect.'' The way to do it would be to create, again, a mystery. He found an empty apartment above his and brought two models together (above) in a situation inspired by the movie *Last Tango in Paris.* ''This is our chance to go through the gymnastics of fornication,'' he told them when they were ready to begin simulating various forms of lovemaking, ''and at the same time we're going beyond that to provoke questions. Why are you in this barren kitchen? Is this your place? What do you mean to each other?''

But he gave up trying to reform sex magazines.

For one thing, he did not feel his approach radiated enough fun. ''Sexual relationships are not totally without humor. If they were, they would *all* be disasters. Some photographers can make it look playful—Giacobetti, J. Fred Smith.'' (See *Photographing Sensuality,* Masters of Contemporary Photography.) Kane left *Viva* in 1974 to return to a studio of his own, not because he finds sex vulgar but because he concluded that its merchandisers depended on vulgar artifacts—the furniture and settings—to sell it. ''If I'm imposing an esthetic in an area that doesn't want it, or even need it, then I've got to go.'' Regrets? None. ''It was an exercise. I get bored if I keep doing the same thing over and over, so I keep making changes. I keep sticking my neck out, and sometimes I get my nose burned.''

*Self-portrait of the loner in
Monument Valley.*

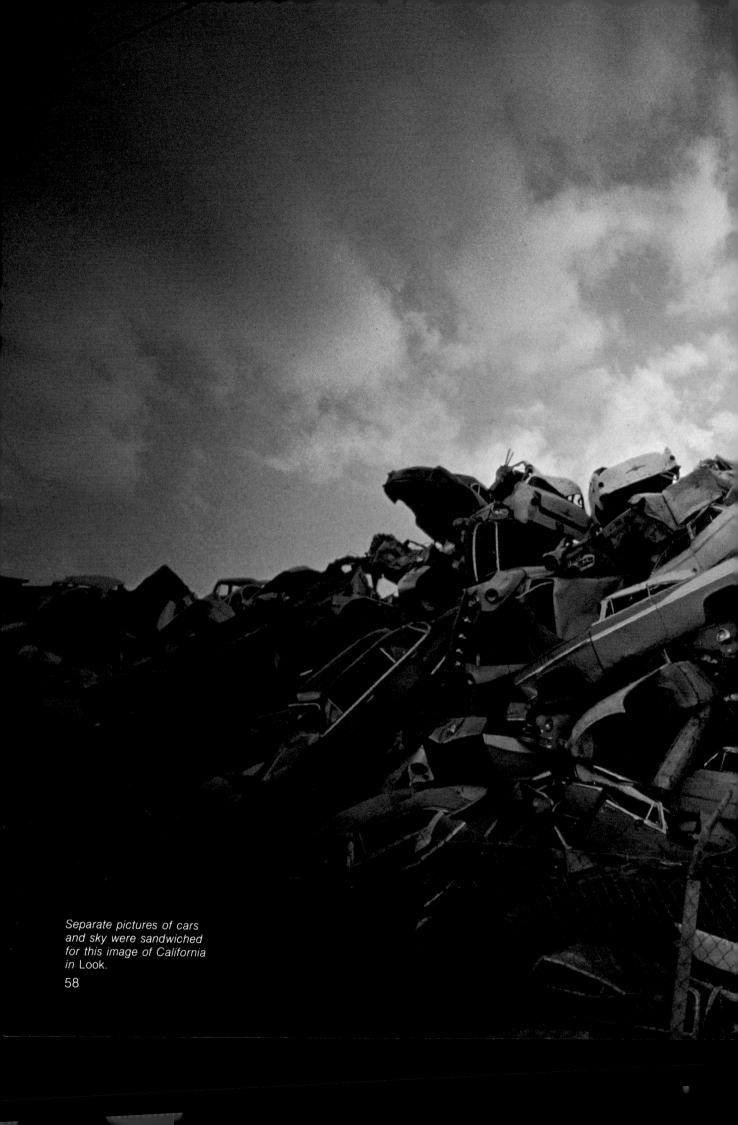

*Separate pictures of cars
and sky were sandwiched
for this image of California
in* Look.

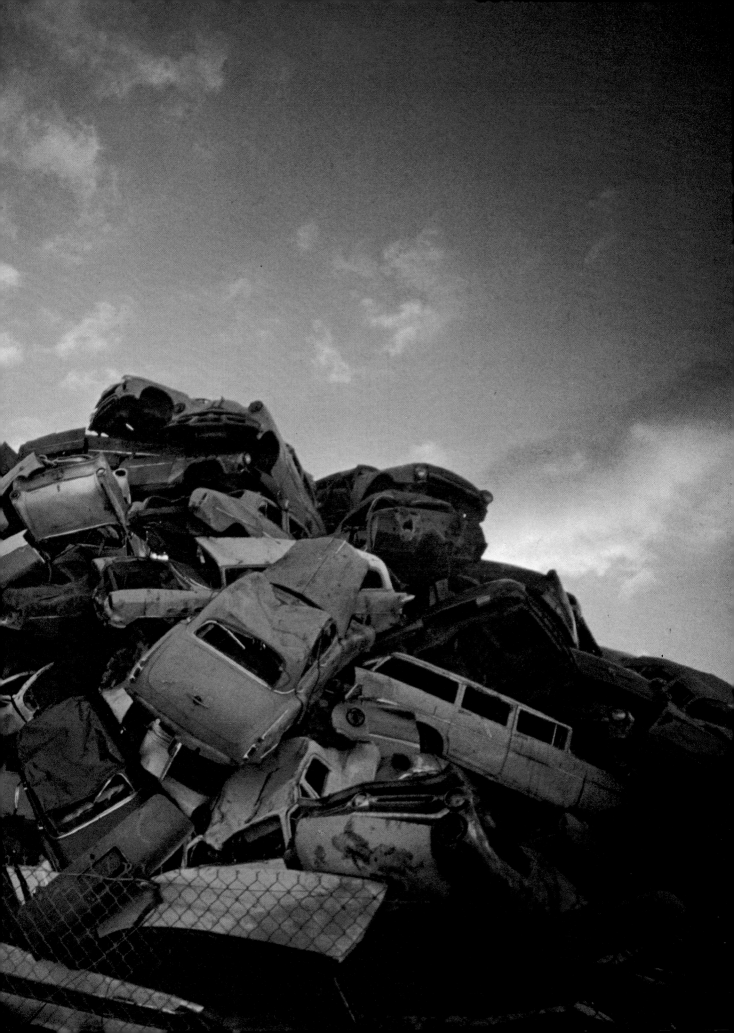

Landscapes: Manipulating Images for Drama

One sideline for many still photographers at the level of Kane, Bert Stern, or Elliott Erwitt is the television commercial. There is money in those films that can subsidize other less lucrative work such as editorial illustration; and for those who want extra travel, there is that.

Kane arrived one evening atop a rock in the Monument Valley of Arizona, where he was simultaneously directing a TV commercial and making advertising stills for Manufacturers Hanover Trust Company. He had positioned an automobile below in preparation for some footage of it moving through the scenery. Now he had to wait 20 minutes for the camera helicopter.

Cast against a rock

turned rust-red by the setting sun he saw an old friend, his shadow. Something about being solitary in a vast landscape touched him. A photographer intent on recording just the scenery would have moved to eliminate the shadow, but Kane, sensing the drama of idea added to appearance, stayed in the sun's way and made sure he got all of what he saw by turning a 21mm wide-angle on it (pages 56–57). Alone again, on the road.

Memories of certain painters echo through Kane's landscapes. Andrew Wyeth, son of his early idol, N.C. Wyeth, speaks through *Christina's World* to Kane's sense of loneliness and search; so do Giorgio de Chirico's nightmare panoramas and René Magritte's challenges to ordinary perception. You might wonder at the apparent ominousness of the photograph at right, with its empty swing and that ring hanging like a noose, even though its literal content is simply a calisthenics group on a beach in Brittany. There on the French coast 5,000 miles from his shadow in Arizona, Kane was on assignment for the travel magazine *Ven-*

Placement of ring and swing, plus vignetting caused by lens shade on a wide-angle, makes a mystery of a beach in Brittany.

ture when he found himself wondering about "the kid who's not with the crowd, or maybe was playing there and went the other way." Again, the depth of field and wide angle of vision of a 21mm lens gathered in objects from within a few feet of Kane's eye to the horizon.

He made one of his favorite photographs (below) on a vacation in Puerto Vallarta, Mexico, employing the 21mm lens this time to drain perspective from the planes of the picture, leaving rectangles of color reminiscent of a Piet Mondrian painting. Many creatures passed through the frame while Kane composed the photograph—a mule, two fishermen, several children—but the independent mutt is the one he chose to keep.

Although Kane does not share the deep amusement that has led Elliott Erwitt to photograph hundreds of dogs (see *The Private Experience,* Masters of Contemporary Photography), he could not resist the design another dog offered him during his *Venture* trip in Brittany (upper right). He was about to photograph a windmill, wondering how to make it interesting, when he came upon "one of those incredible strokes of fortune." The dog was sitting in the field, and that was mildly interesting. As he moved up,

62

instead of running away it turned its head. "What elevates the image," Kane says today as he looks at it, "is the impeccable posture of that dog. The windmill faces right; the dog faces right; it makes a very still picture. If I were to paint the dog from the start, I couldn't have arranged it better." At first he remembers using a 50mm lens but then, looking at the reach of the dog's foreleg toward the bottom of the frame and the sharpness of the clouds far beyond, he changes that to 35mm.

It is one of the few pictures that Kane has "found" rather than made. He might find more

One of Kane's few "personal" photographs.

if he were to shoot more for himself—to record observations in the manner of Erwitt, whose realistic "personal" photographs of dogs and droll humans make up a hefty portion of his life's work.

Erwitt and Kane get along all right, but they live in different photographic camps. Kane's interest in personal snapshots is limited, for one thing, by the use of his pictures to persuade a broad audience toward some point of view, even when they contain bits of himself. For another, "I need a patron. I have really got to determine why my adrenaline starts pumping when somebody says 'Go.' Is it the challenge of the assignment, or it is just because somebody's pay-

ing me well?"

Why not both? Witness the indictment of wastefulness on pages 58–59. Kane had gone to California for *Look* in 1966 to portray the state as both heaven and hell. Cruising a freeway near Oakland, he spotted a gigantic heap of smashed automobiles. An idea began to take shape as he poked around it. Every high school student in the state seemed to have a car, and people with an insane desire for speed were killing themselves daily. He saw a ceremonial pile of bodies, a huge sacrifice to the devil. He knew, of course, that even with the help of his then-favorite 21mm lens the camera was seeing just

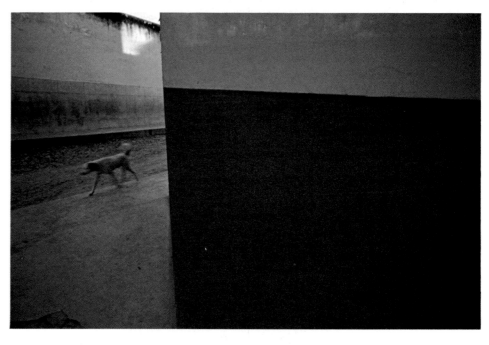

another pile of demolished autos under a gray midday sky.

It needed something. Back in his studio a few weeks later, Kane found a photograph of sunlit clouds and sandwiched it over the cars, heightening the drama of the image just as Magritte had made an ordinary dark street terrifying by putting a nice blue sky over it in his painting *Empire of Light, II.*

The *Look* writer who had watched Kane take the picture was startled not by the sandwiching but by the cropping. In the projection room where Kane was presenting his choices, the writer said, "Hey, Art, I was so impressed by the size of the pile. Why not run the cars higher so they look like more?"

"Because it's an emotional big we're after, not a physical big," Kane told him. "The light and the dark do it. That sky does it."

Even with a sandwich, Kane cannot stop caring about natural light. "It's the only medium we have to work with. In a sense it's God. Religious paintings always have emanations glowing around the deities. If the light is wrong I can't get turned on no matter what's in front of me; I'll wait until it's right." In more than 90 percent of his pictures, that means refusing to bring in electric light to correct awkward sunshine. "It has to

The dog arranged itself. For once, all Kane had to do was take the picture.

do with a reverence for light and a disrespect for General Electric and Con Edison."

He has rejected assignments for a number of reasons, including a feeling that they did not allow leeway to avoid shooting at high noon or to wait in case the light turned harsh. But a professional cannot always be choosy, and even Kane keeps a studio where conditions can be pretty much guaranteed. His studios have always had large north-light windows and diffusion materials—spun glass, plastic shower curtains—to let him manipulate what the sun provides. In or out of the studio, he seldom uses reflectors to fill shadows. "A lot of people fill and balance because in commercial photography *information*

is required: You must tell how many buttons a dress has. But there is something about a perfectly lit photograph that I find offensive. If the light happens to drop off, so be it. That might produce a certain mystery. I'm interested in withholding some information—in not spelling things out so clearly that they become dull and cold."

Meticulous as he is at some levels, Kane is a gambler at others. Walking around his country house, he keeps his head up; if there is a rock in the path, he is the man who will trip on it. "And I work that way as a photographer, too, not observing too carefully where I'm going, because tripping over the stone might just lead to something marvelous. So what if you get cut up occasionally? I hate to feel that I know exactly what's going to

happen. When something becomes predictable, like when I control the light by using a strobe or whatever, then it begins to bore me."

And yet . . . Producing the pubic hair pictures had been fascinating, with all that strobe. So had the production of a beauty spread for *Viva* in which he duplicated the look of a Richard Lindner painting (pages 8–9). Lindner's prostitutes and middle-class women preoccupied with makeup have long been favorites with Kane, so he gathered a makeup-and-hairdressing team, put spun-glass hair and a specially made beret on a model, and then stood her in front of a white wall. He even added to the length of the wall with white paper so that the light from four big strobeheads would bounce evenly and wash everything flat. After bracketing the shot he discovered that an overexposure gave him what he wanted—another change from most of his work, in which he has always liked to underexpose by a stop to get deep color saturation.

So it was that when he set up his new studio early in 1975, Kane bought several thousand dollars worth of electronic flash equipment— perhaps as a new toy, perhaps as a real tool for a new stage in his work. "Maybe I've been denying myself something

63

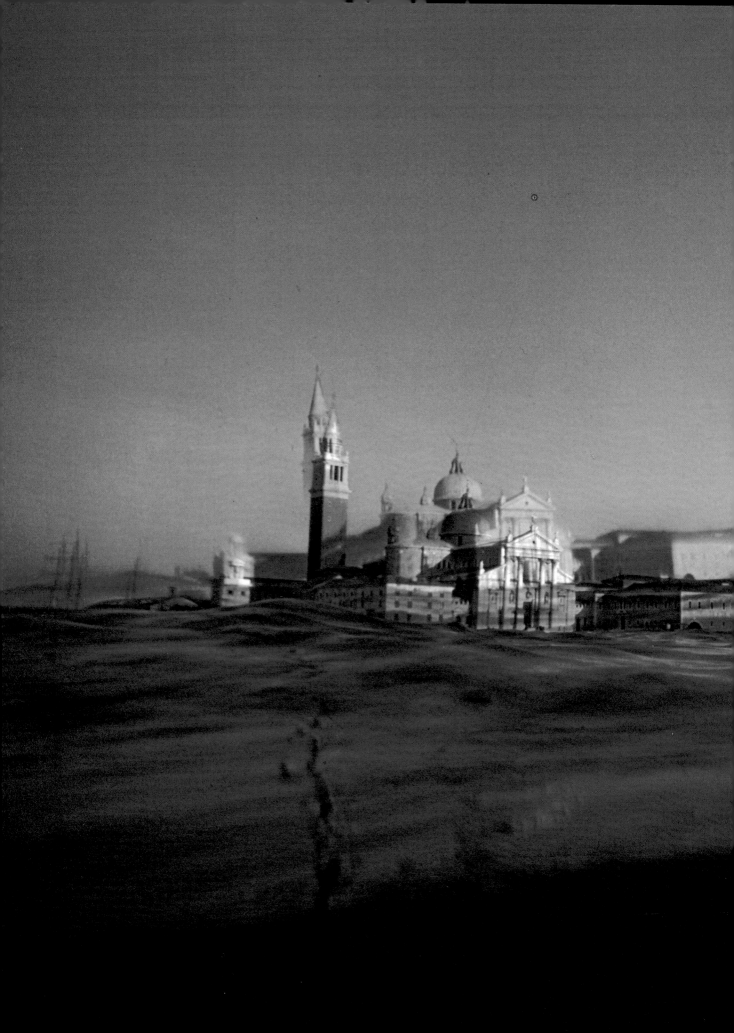

Kodachrome gives blues richer than those in nature. Kane used that property of the film, plus one of his best sandwiches, to rally help for Venice.

good.''

There was, however, no way he could have used artificial light in the set of photographs that remains one of his most satisfying, a *Look* essay on Venice.

It grew from Kane's relationship with Allen Hurlburt, art director at *Look* until Will Hopkins took over in 1968, when Hurlburt became design director of *Look's* parent company. Hurlburt had known Kane as a fellow art director. Before Kane had truly proven himself as a photographer, Hurlburt was the first to respond to his brash theories about using photographs poetically to illustrate ideas. A suggestion from Kane led to a famous *Look* essay, ''The Power of Words,'' and they developed concepts together until *Look* disappeared in 1971.

''Allen has a way of assigning the right guy to the right job,'' Kane says in admiration. ''He trusts them with a minimum of briefing.'' For his part, Hurlburt was impressed by Kane's perception and bold use of color—and even more by ''his ability to think in terms of reader involvement. In his early career as art director of *Seventeen*,'' Hurlburt has said, ''it was clear that he was more than an arranger of the printed page. The editorial judgment he demonstrated has continued into his work as a photographer.''

It was natural that the two would get together with Hopkins when the world realized that Venice was being destroyed by air pollution and water. Magazines everywhere took up the story, trying to raise funds for preservation work. *Life* showed water levels and faces flaking off marble statues—the literal truth of what was happening. For *Look,* Kane was interested in a more dramatic truth, ''the *essence* of what's happening.'' He wanted images that would cry out and move people to help. ''I want you to know what it would feel like,'' he told Hurlburt and Hopkins, ''if Venice suddenly succumbed to the Adriatic and you could see this incredible city sinking.''

He would topple the obvious symbol of the city, a section of waterfront silhouetting the campanile and cupola of the Cathedral of Saint Mark, into the water. Obvious, but corny ''only if you stop at just pointing a camera at it.'' Kane intended to transform the symbol. To do that (preceding page), he leaned over the rail of a ferry going from Venice to its offshore beach, the Lido. Inside a specially built waterproof housing, the camera was submerged two or three inches as he aimed back at the landscape, tilting to a new angle and bracketing with each exposure.

Kane later sandwiched two almost identical frames from this take, using a normal exposure and an overexposure—a combination he has favored since ''The Power of Words.'' The entire Venice essay consisted of montages: A clear but tilted shot of the Piazzetta of Saint Mark's flopped upside down and sandwiched over a duplicate of itself, then married again to a picture of water (top left); a straight picture of a seventeenth-century church overlaid with a photograph of water (bottom left). Duplicate transparencies of the Piazza of Saint Mark's were superimposed, one upside down, as a tribute to the space of the square and

H old in your mind for a moment the abhorrent vision of rising sea and impending smog as the jaws of an elemental pincers. If it closes, it will cut off life in sublime Venice. There, as for over five centuries, the glorifying art of the Renaissance stands in Renaissance houses raised by Renaissance men at the heart of God's best lagoon. And there, awful to behold, now stands proof that art need not endure. Like an old Doge of great dignity trying to bow out before an enemy overwhelms, Venice slowly sinks on its subsoil as the sea around slowly rises. Ruinous hordes are thick in the city's air. Unless some plan cuts them off, pollutants that crumble marble and dissolve paint, even in the Piazzetta of St. Mark's (right), will leave only memories for the Adriatic to cover in decent burial.

PHOTOGRAPHS BY ART KANE

Floodgates will help, stone can still be saved by protective coatings, some paintings

E ver since Venice began to fail, living in it blinded eyes to observable fact. Venetians have long let scholars calculate each year's loss in splendors while they count the gain in tourists. But the prospects of permanence are so reduced that even the Venetians are alarmed. They have cried for help to official Italy and asked analysts from any quarter to uncover cures, while passing the word to all that their city can be saved only by very large offerings of funds.

They would set sea gates at the harbor entrances to wall out flood tides that cover the steps of Santa Maria della Salute (right). They would coat walls and statues with new chemical protectives against soot and salt. But when all that is done, the Venetians will admit that nothing can bring back the glory that is irrevocably gone.

Venetian sea traders who flourished centuries back ordered beauty to appear all around them. Maybe money was never better spent. One of Andrea Palladio's purest plans took stone shape in the church of San Giorgio Maggiore (over). Tintorettos and Carpaccios consecrated walls there, and Titian and Tiepolo worked miracles in classic *palazzos* nearby.

Merchants now value old Venice mostly as the fabled gatehouse huge ships pass on the way to Marghera—the rampaging industrial port a few more miles inland. Once, Marghera was a proud capital's trifling suburb, but it is now blamed by many for all that fouls Venice. Others know that the prevailing sea breezes push factory smoke the other way, and that most of the damage in Venice can be traced to fumes of its own fires.

continued

...ways be restored, yet time has already run out for many of the invaluables of Venice

What comes over the visitor to a desperate Venice is the ache of envy. That, and a sadness for progress. There the city stands, all stately by the sea, an imperiled testament to privilege, even to tyranny. Plunder by a few brightened life for many. The means were shabby, but the ends were all excellence—the ducal palace, the Byzantine basilica, a stronger campanile tolling prayers where the old one crumbled. All these stand in the great *piazza* (over), sentinels at a deathwatch, or suppliants crying out that they can be saved. The visitor envies the age that gave them value, then is sad that no age valued them enough. One honors them now with poor concern, but they honor time past with foolish endurance and their mute hope that they grow old with grace.

continued

to Renaissance perspective drawings that had impressed Kane as a boy (next page).

Not that he knew he would be sandwiching when he went. Kane arrived in Venice intending to dive into a canal with his waterproof housing, not realizing how filthy the water of the canals is: "It was like shooting through ink." He gave that up for the cleaner water of the Adriatic, and also tried a few other approaches. If Venice were completely flooded, he figured, thousands of the city's hated pigeons might drown. So he paid a couple of boys to bring him 200 dead pigeons, which they did the next morning, dragging plastic sacks of white corpses through the lobby of the elegant Gritti Palace Hotel to a gondola dock out back. Kane and his gondolier dropped the pigeons, one by one, into the water, and he shot until the canal was clogged with bodies. It stayed that way for days.

Or perhaps one would see priceless paintings floating in a canal. He bought three cheap but convincing reproductions from an antique dealer, got back in the gondola and dumped them overboard. Nobody had complained about his littering with the pigeons, but this time Kane was arrested; somebody called the police to tell them that a *molto stupido* was destroying a great work of art. Even before the arrest, Kane himself was rather taken aback. He had not realized that the water in the canal was so devastating: It lifted the paint right off the canvas.

None of those images worked. They were all too literal. So that's what a painting would look like if it fell into a canal.

So that's what 200 dead pigeons look like. So what? They looked messy but not horrifying. Kane had gone to great trouble to prove once again that his own approach to photography is best for him.

"Montage is just one way to communicate, like a wide-angle lens or an overexposure. A tool. I use it as a poetic tool to escape from photo realism. Unlike the journalist who records what went on, who was there, a poet sums things up in a more personal kind of statement. It's like life itself. Things happen but they aren't necessarily dramatic until you stand off and draw their essence out of your memory. Memory is beautiful. So I can't really shoot realistically. I need devices to break away from what we think is normal vision.

"Once you have the audacity to extract an image from the living breathing, totally dimensional world, you've eliminated smell, touch, sound—and you've put a frame around it and eliminated peripheral vision. In that sense, no photograph is the truth, no matter how realistic an image is, no matter how normal the lens, no matter how unaltered the image. They all lie. "We're always montaging. In normal vision we see one thing at a time but we're moving our eyes and combining things continuously. I'm looking at you, and I look out the window, and in a split second I've put three images together. It's snowing outside, you are in the room, there is a fireplace. Putting one over the others might say something about this weekend. At least the poetic side of me thinks it would."

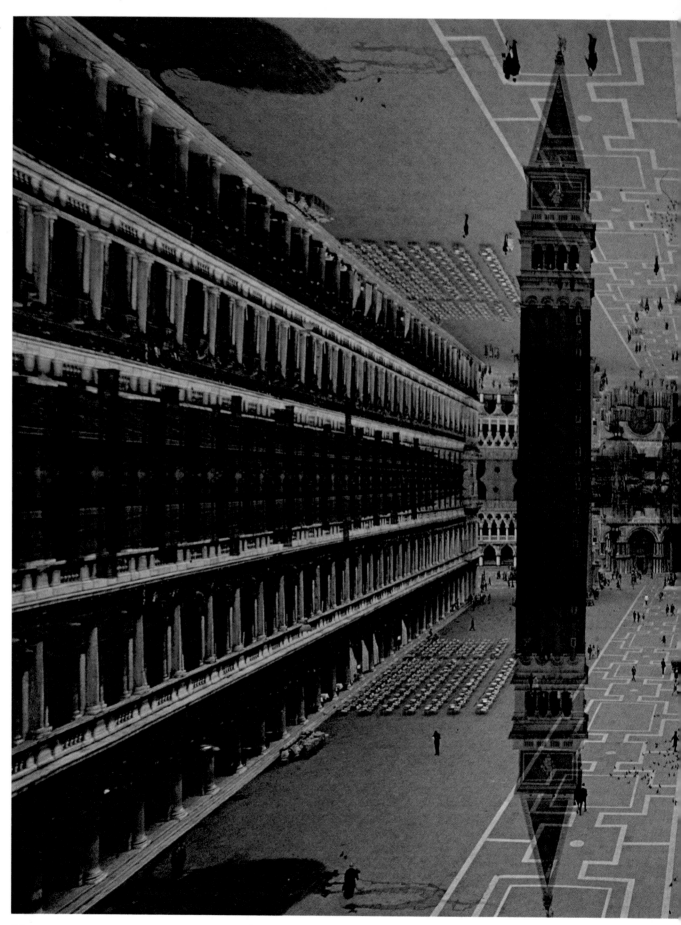

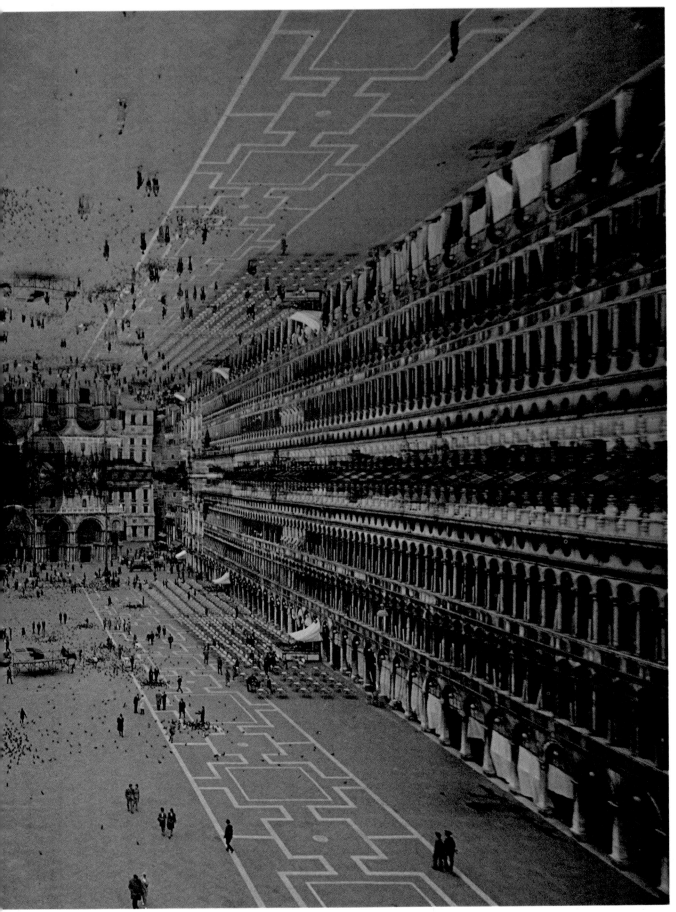

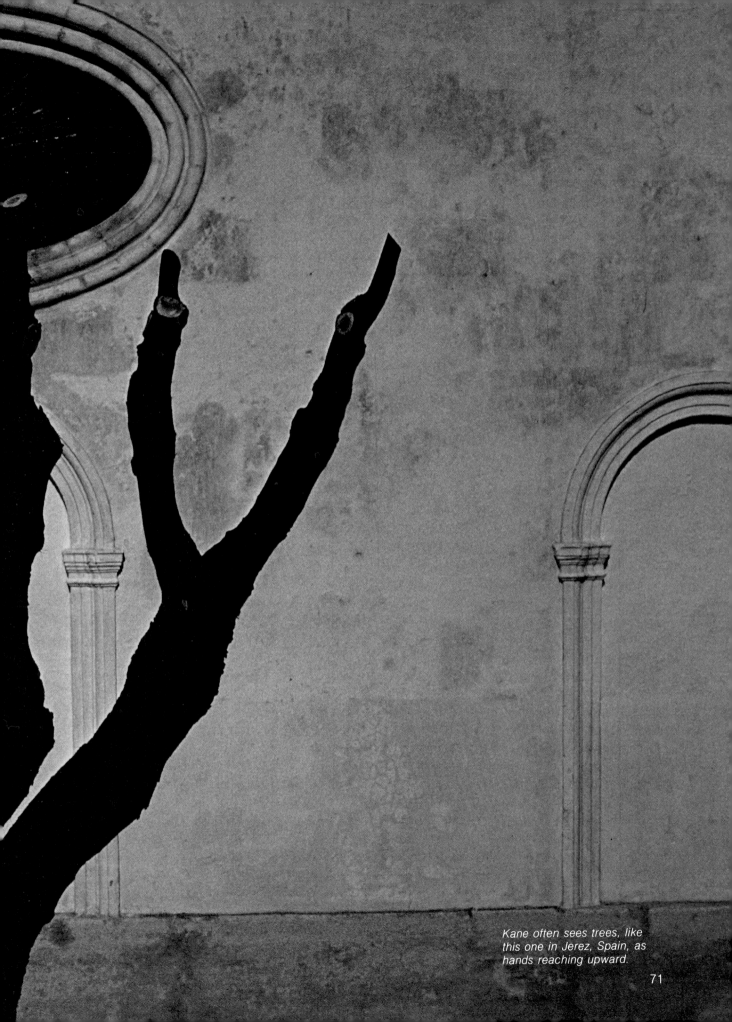

Kane often sees trees, like this one in Jerez, Spain, as hands reaching upward.

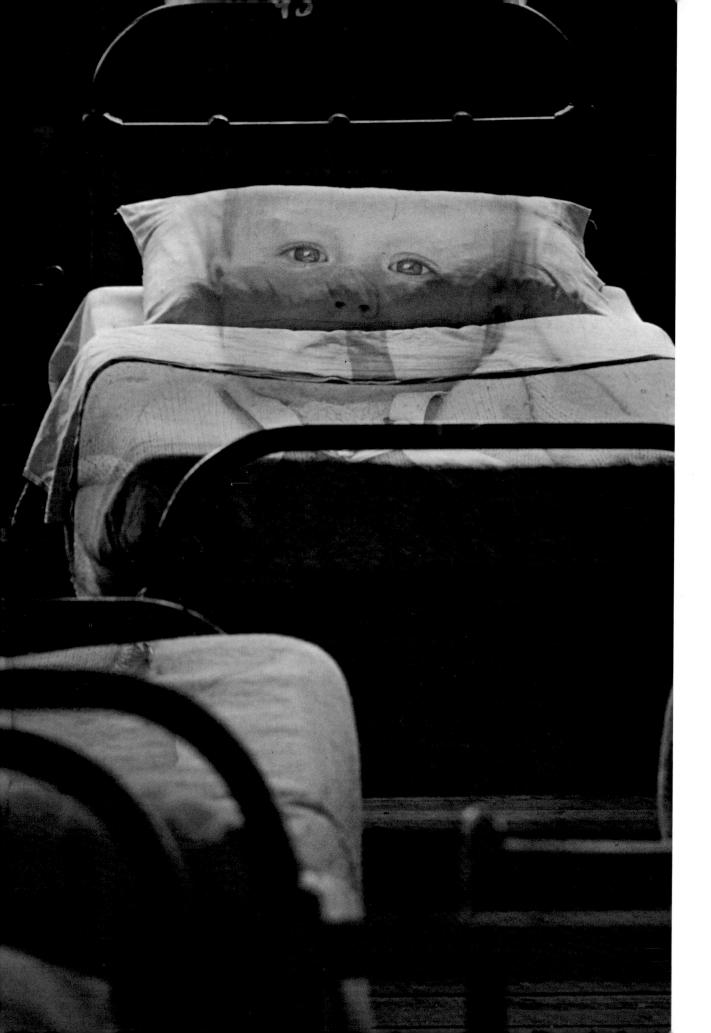

Technical Section

When Art Kane takes a picture, he is most often interpreting an idea, illustrating a concept, offering a well-designed image of striking beauty or visionary creativity to the viewer. He explains that he is not interested in the way things look, but in the way they make him—and the rest of us—*feel*. Kane deals in illusion, in photographic impressionism that reads quickly, tells a story, stimulates emotion or distills an idea into a memorable pictorial essence.

Art Kane's photographs are made with a persuasive point of view: Venice is in peril, rock singers have a message for us, loneliness is universal. Kane is a visualizer who delves into a fantasy world that seems to amplify reality. His approach to converting concepts to images is easier to understand than to emulate, even though his photographic techniques are disarmingly simple.

If you tend to think of Kane as predominantly a New York studio photographer operating behind huge banks of strobe lights and surrounded with esoteric equipment and accessories, forget it. Most of the pictures in this book were

Seeing the Beatles song "Lady Madonna" as a contemporary Mother Goose rhyme about abandoned children, Kane sought out the elements of this sandwich in institutions near London.

taken with natural light, on improvised sets or outdoors. All but a few were shot with 35mm single-lens reflex (SLR) cameras equipped with various lenses. Where many photographers, especially those in stages of learning the art and craft of the camera, are validly involved with film and print processing, filters and offbeat techniques, Kane uses few gimmicks and is content to trust Kodachrome, which cannot be pushed, juggled or otherwise manipulated. True, his methods of exposure are sometimes unconventional, as we shall explore, but his emphasis is on preproduction, the thorough planning of pictures before exposures are made, and the one postproduction activity to which he devotes long hours is choosing slides for sandwiching (combining images). We will find out how he goes about this later in this section, but first let us examine Kane's cameras, lenses and exposure techniques.

EQUIPMENT

One photograph in this book, spread across pages 36–37, was shot with a 2¼x2¼ Hasselblad camera

with a normal 80mm lens. It was done in the late 1950s as one of the first professional assignments Kane had (from *Esquire),* and he rather innocently approached the ambitious complexity of including such a mass of musicians and children in one group picture. His camera was on a tripod, he didn't worry very much about the angle of light, but he did choose the side of the street without bright, squinty sun that would have made his subjects uncomfortable and added harsh shadows.

That photograph, and those of Louis Armstrong on page 38 and Charlie Parker's gravestone on page 39, represent the major exceptions in regard to cameras. Most of Kane's pictures are taken with Nikon cameras, either the F or the F2. Another exception is the beautifully distorted elevator interior at the bottom of page 47. This was made with a Konica T3 because of its unique 15mm f/2.8 fisheye lens that is designed to fill the entire 35mm frame, unlike other super-wide-angle lenses that offer a round image or darkened corners. Blue light in the elevator was the source of

illumination on Type A Kodachrome, and no filter correction was attempted because Kane wanted that luminous blue atmosphere. The shot was part of a brochure for a new office building.

So much for exceptions. After branching out from his earliest 2¼ × 2¼ cameras, Kane had only the normal 50mm and a 35mm wide-angle lens for his Nikon. These, incidentally, are often first choices of SLR owners. The 50mm is okay (not ideal) for portraits, and the 35mm is fine for places where you can't move back, or need more depth of field. (The shorter the focal length of a lens, the greater its depth of field at a given aperture.) For openers, people may also choose a medium telephoto lens such as the 105mm or 135mm, along with or instead of the 35mm lens, because these provide good portrait perspective and "reach out" to record portions of distant scenes.

Kane's next acquisition was a 180mm f/2.8 Sonnar lens that has not been manufactured for many years. It weighed several pounds, but offered a wider maximum

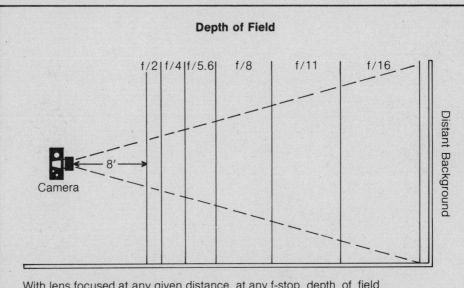

Depth of Field

f/2 f/4 f/5.6 f/8 f/11 f/16

Camera ← 8' →

Distant Background

With lens focused at any given distance, at any f-stop, depth of field (area of acceptable sharp focus) increases as lens opening becomes smaller, i.e., as lens is stopped down.

aperture than the usual f/3.5 or f/4 lens available at the time. Today there are two newer 180mm f/2.8 Sonnars on the market (from Camera Specialty Co. and Exakta Camera Co.) plus several others from Nikon and Leitz. If you can be satisfied with an f/3.5 lens, however, there are more 180mm models from other makers, plus many zoom lens combinations that include the 180mm focal length.

Kane was one of the first professionals to fully explore the SLR medium in terms of selective focus. He experimented with opening and closing the aperture, watching the area of sharp focus change through the finder. Any long focal length lens, starting perhaps with the 135mm, allows you to make similar choices in sharpness of a main subject contrasted against a soft-focus background, if you shoot at near-maximum aperture and focus critically. An example is the sharply outlined figure on page 51, with its soft-focus background.

These effects are also possible with a 35mm range-finder camera or a larger format SLR (such as the Bronica, Hasselblad, Kowa or Mamiya 6x7), but keep in mind that the rangefinder camera limits you to 135mm as the longest focal length unless you add a reflex housing. Selectivity of focus with a rangefinder is not as precise, since you are not viewing through the lens.

At the same time he was using his 180mm lens for portraits, Kane was using his 35mm lens for complete overall sharpness. "You go to extremes." And soon he fell in love with the 21mm lens that he used for a number of images in this book. At first he chose the 21mm to make closeups and to exploit its inherent image-bending qualities. Several assignments illustrate how Kane's individual vision made the most of unusual optics.

FASHION
[page 47, center]

Art director Alexander Liberman asked Kane to shoot some fashion jobs for *Vogue*. Kane decided he would give the subject a 21mm super-wide treatment, distorting the models and perspective within the 35mm frame in a way that fashion had not been approached before. The middle picture on page 47 is a strong example of the look with which Kane blazed a trail and caused wide comment. For a short period 21mm fashion was a Kane trademark.

The photo at the top of page 47 also illustrates both functional distortion of perspective and complete sharpness from edge to edge, top to bottom, created by the 21mm lens. This photograph was part of an assignment for *Queen*.

JOE LOUIS
[page 83]

When Kane took an assignment from *Esquire* to photograph former boxing champ Joe Louis, he recalled his early images of the man with bulging muscles, "once the most beautiful, strongest man in the world." Thus his first urge was to invite Louis to his studio, have him strip to the waist, and visually echo past physical impressions. Not surprisingly, Louis refused, and Kane realized belatedly that he might be embarrassed. Quickly shifting his approach, Kane decided that a bundled figure in a large overcoat with huge fists was the way to go instead. The optical characteristics of the 21mm lens achieved the effect. As an interpretive portrait it has become famous, not only for its unusual perspective, but for a spiritual feeling that Kane often seeks.

Mirror Optics: After his 21mm period tapered off, Kane became enamored of the compact 500mm mirror reflex lens, which took him back to extreme selective focus. "Again the incredible soft backgrounds," he recalls. "That lens influenced me and altered my vision."

Lens design dictates that the longer the focal length, the longer the lens barrel. Extremely long telephotos, such as a conventional 500mm lens, become unwieldy monsters to carry and use. You may have seen pictures of a 1000mm or 2000mm lens mounted on several tripods, looking like a cannon, deserving its nickname, "Big Bertha." The advent of mirror reflex lens design was a boon to photographers. Such a lens uses several mirrors within a large-diameter, relatively short barrel (see diagram). Light is refracted (the rays are bent) from the back mirror surface to the smaller mirror in front, and then through another lens and into the camera: hence the *reflex* designation for a lens that is light enough in the 500mm version to hand-hold at fast shutter speeds.

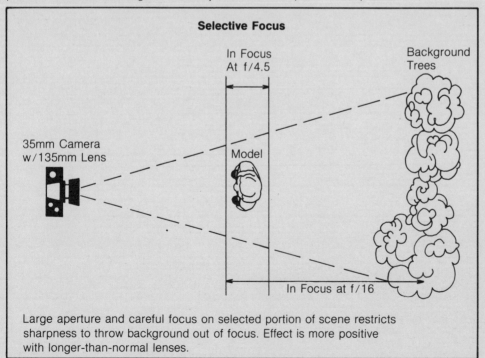

Selective Focus

In Focus At f/4.5

Background Trees

35mm Camera w/135mm Lens

Model

In Focus at f/16

Large aperture and careful focus on selected portion of scene restricts sharpness to throw background out of focus. Effect is more positive with longer-than-normal lenses.

Mirror Optics Principle

Image or Light Rays

Mirror

Mirror

Lens

Camera

Lens

Film

Lens

There is no aperture adjustment in a mirror reflex lens, so one shoots at f/8 with very little depth of field, and out-of-focus highlights appear as tiny doughnut shapes.

Mirror optics in the 500mm category, as well as several longer focal lengths, are made by a number of companies. The Nikkor lens Kane uses now lists around $500, and it may be amusing to learn that the 2000mm Reflex Nikkor lists for $6,890.

In addition to those mentioned, Kane also owns and uses lenses including a 28mm, 105mm and others, plus a 50mm Macro Kilar which he recently discovered was "defective." Just what optical disease it had is not certain, but when Kane passed it on to a friend, he was left wondering "if the defective qualities of that lens produced some of my better pictures." This is typical of the unorthodox detachment Kane displays toward his tools, which are simply a means to a creative end.

Notes On Exposure: In these days of built-in camera meters, we are accustomed to watching a needle and making the usual aperture and shutter speed adjustments (or making a setting for automatic operation) to achieve proper film exposure. Some professionals,

including Kane, prefer using a hand-held meter, claiming that its accuracy or selectivity suits them better. Since different exposures can produce quite different effects in a finished picture, particularly in its color quality, Kane

uses a specific technique to assure him of a choice when his film comes back from the lab. It is called *bracketing.* This means setting a basic exposure (using a meter) and varying one-half stop, one stop, or more, both over and under the first setting. For instance, if your meter indicates 1/125 second at f/8, shoot at f/6.3 and f/5.6 for overexposure, and f/9 and f/11 for underexposure.

What effects may you anticipate in color? *Overexposure* tends to lighten colors or reduce their chromatic saturation, making them more and more pastel. Excessive overexposure is termed "washed out," which is annoying, but you may not be sure in advance if a setting is excessive. *Underexposure* tends to darken colors or increase their satura-

tion, making them deeper and often more dramatic. Kane tends to favor saturated color, which comes from underexposing about one stop. He might bracket as much as three stops on either side of a beginning exposure.

LAY LADY LAY
[pages 4–5]

This is one of two differing examples of bracketing to further illuminate Kane's practice. Earlier in the text of this book Kane tells how the room was chosen, painted and decorated to illustrate

THE EFFECTS OF BRACKETING

Exposure	Color Slides	B&W or Color Negatives	B&W or Color Prints
Normal	Hues okay	Good density	Excellent tones or colors
Overexposed ½ stop	Hues not quite bright enough	Too much density, but easily printable	Usually acceptable B&W tones and color as well
Overexposed 1 stop	Hues become pastel, washing out, losing detail	Too much density, tones run together; difficult to print	Grain becomes noticeable; definition is impaired, contrast increased, colors not true
Overexposed 1½ stops	Pale, color may be difficult to see	Excess density makes printing very difficult	Excess grain, tones and colors inferior
Underexposed ½ stop	Hues slightly dark, but color saturation is sometimes welcome welcome	Too little density, but printable; shadow detail missing	Usually acceptable, but B&W tones and color shadow details are affected
Underexposed 1 stop	Hues darker than normal, some shadow detail missing; *dramatic color saturation, often favored by professionals*	Too little density and shadow detail	Prints possible in B&W with high contrast papers; color prints murky with degraded hues
Underexposed 1½ stops	Hues usually very dark, with no shadow detail	Density missing; negatives "thin" or too transparent	B&W prints possible but shadow detail is missing; color prints inferior

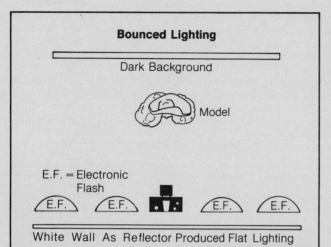
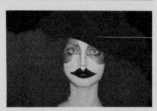
the lyrics of a Dylan song. He knew that in late afternoon the light would be flooding through the windows, and he anticipated its beauty and appropriate quality for this subject. With this certainty, Kane shot several hours of pictures until he had an enormous number of variations in terms of camera angle, the model's pose, and the glow of light. In each situation he bracketed at least one stop over and under in a well-directed exercise of trial and error. He knew the mood and feeling he wanted, and stayed with it until he was sure he had achieved *the* image that fulfilled his original idea.

As a technical aside, the hazy definition in the upper right was accomplished simply by dabbing a small amount of oil from his nose directly on the lens. Kane could see the effect in the finder and wipe off any excess or add more until it was satisfying. If you prefer not to grease your own expensive lenses directly, you may try dabbing a small amount of Vaseline on a clear (UV) filter in front of the lens, and varying the position and amount until you see what you like.

LINDNER HEAD
[pages 8–9]

To echo the style of painter Robert Lindner, Kane (with the help of "a talented hair

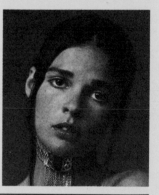

stylist and a great makeup artist") bracketed his electronic flash exposures for a different reason. His experiments showed the need for a large amount of light reflected from a wide white wall to achieve the very flat illumination desired. After making a sequence of varied exposures, Kane found the best Kodachrome slide had received more exposure than an electronic flash meter called for. Only by bracketing was the photographer certain of success to warrant the time and effort.

The Ever-Present Motor Drive: A number of 35mm SLR cameras can be fitted with electric motor drives which will not only advance film at an average rate of 3–5 frames per second, but in the case of the Nikon F2, will also rewind the film when set in reverse. Ordinarily, the fast sequence type of pictures possible with a motor drive are most valuable to sports and action photographers who want to catch peak action which might be missed while advancing film manually. Kane does not fall into

the action or news category, yet he consistently shoots with a motor-driven camera. Why?

"I love the feeling of the camera," he states, "and who wants to be distracted all the time while advancing the film with your thumb? The extra noise doesn't matter, because I'm not sneaking up on a subject, and there's no weight factor when the camera's on a tripod. It's just terrifically convenient, and I can concentrate all the time on what I see in the finder with no momentary breaks." It makes sense for a professional whose time is paid for at a premium rate. A motor may be valid for anyone who shares Kane's feeling for its convenience, and who wants a better guarantee of catching those fleeting "in-between" expressions or movements of a mobile subject.

"The joy of photography for me has never involved the technical aspects," Kane says. "Other than sandwiching, the whole trip for me is preproduction, concept, thinking, planning, getting it all together, and click—and it's off to the lab."

FOR THE LOVE OF LIGHT

Art Kane appreciates the fact that "natural" light comes in many delicious flavors. Outdoors his favorites vary from low-angled sunlight

to the softness of an overcast day. Indoors his taste runs to window light glowing on people in empty rooms where walls bounce the illumination around and soften shadows. Kane's artful choices of settings where the light is lovely can be deceptive because they seem so obvious. Learning about the type of light he looks for and how he makes it work is both revealing and stimulating. Examine some specific cases:

ALI McGRAW
[page 1]

Kane had known Ali Mc-Graw a long time before he photographed her following *Goodbye, Columbus,* her first film. He chose an old mansion in Newport, R.I., as a location, and this portrait is her reflection in a mirror. In this interesting aside about handling people, Kane says, "I've discovered many times that direct confrontation is

Shooting into a Mirror

Tile Wall

Tile Wall As Reflector

Windows

Camera was angled to avoid Kane reflection

Mirror

not as conducive to allowing a subject's true emotions to come out. A mirror lets someone see her own image and react to herself. It sometimes inspires moods or expressions that are not brought out by sheer frontal contact with the glass eye of a camera."

Ali viewed herself in the mirror of a huge and elegant bathroom where daylight bounced off old yellowish tile walls to become even more mellow. The portrait reflects her uncertainty at that time, when her first film was released, but indirect or reflected light is almost always flattering and easy on your sitter, no matter what mood you wish to express.

JEFFERSON AIRPLANE
[page 19, bottom]

For this *Life* cover, Kane ordered a transparent set of plexiglas boxes in which the rock group posed in front of a large area of gypsum rock along a waterfront just opposite the United Nations building in Manhattan. He chose an overcast day when people and background would blend harmoniously instead of being separated by strong shadows. Kane rarely uses filters, but it may be worth trying a Skylight filter in such situations, because this type of daylight is colder than straight sunlight; a filter helps eliminate blueish tints.

JIM MORRISON
[pages 24–25]

The late Jim Morrison of the Doors was pictured in the closet of Kane's hotel in Beverly Hills. Kane arranged to have the TV antenna and electrical cord extended into the closet where "the tube covering his chest area almost suggested an x-ray image of his nerve center—his thoughts." Using Type A Kodachrome (ASA 40) balanced for artificial light, Kane had the closet bulb replaced with a bare 500W photoflood that would

give him correct color rendition. His assistant made film and exposure tests first, and Kane shot at 1/30 second and 1/15 second, the re-

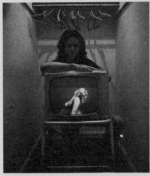

quired shutter speeds to record TV images without objectionable bars of gray that occur when camera shutter and TV scanning rate are not in synchronization. TV picture channels were changed frequently in what Kane calls "a marvelous game of chance"—upon which Kane often relies—and a relatively simple setup became a memorable series of photographs.

LOUIS ARMSTRONG
[page 38]

Kane was under the influence of several personal compulsions which combined to help him conceive

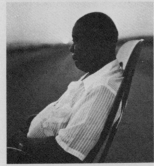

this moody photograph of Louis Armstrong. He was tired of the stereotyped, puffy-cheeked horn-blowing portrait complete with sweat on forehead. Having to shoot in Las Vegas, he wanted to avoid the usual image of bright lights. He planned in advance to show Armstrong in a relaxed and passive at-

mosphere in keeping with his age and stature.

Late afternoon light (which Kane helped to popularize among photographers) was vital to his concept, so late the next day Kane and his subject flew to the open desert. Since this was one of his first photo assignments, Kane didn't totally trust 35mm yet, so he used a Hasselblad with Ektachrome film (ASA 64), knowing he would crop the square picture vertically.

CHRISTO DISAPPEARING
[pages 40–41, bottom]

Here's a Kane solution to an interpretive problem that may look a bit mysterious, but is actually quite simple in

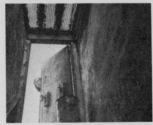

technical terms. It is a direct demonstration of the industrial designer's adage, "form follows function." Christo is an artist who is fascinated by the idea that nothing lasts, that most everything is perishable. "I discovered he was really interested in life-death cycles, so I just made him disappear in four stages," explains Kane. Using the exit of the artist's loft, Kane set his Nikon on a tripod. Beginning with an exposure for full detail, he made a series of overexposures to make Christo fade away as his image on film bleached white. In keeping with Christo's obsession, he himself became fragile and disappeared. This effect is very positive when shooting color slide film, but a negative material (black and white or color) tends to "block up" totally, becoming excessively dense with overexposure, making a similar illusion a lot more difficult.

MAKING THE SLIDE SANDWICH

In this era of frequent multiple and manipulated images, it is enlightening to learn new paths away from straight photography. In one such technique the film is exposed twice or more *in the camera*, with the photographer making allowances for overexposure by closing the aperture one stop or more each time, depending on the number of overlapping images. Kane avoids this method because it leaves too much to chance for his taste. He consistently leans toward as much control over the final picture as possible. Kane prefers to sandwich two frames of already exposed slide film together to create a combination image that is stronger than either shot could be separately.

Motivated by the belief that "you just can't shoot it like it is" when illustrating ideas, Kane has made an artful science of sandwiching. For him this form of multiple image, often very subtle, becomes a welcome device "to transcend the deadly reality of the medium." He does not regard photographic realism as objectionable. He feels that a literal image from the camera of a Cartier-Bresson or Bruce Davidson can be brilliant, but a sandwiched image is often *his* personal way of achieving a symbolic effect. He uses sandwiching (another name for montage) as a means of expression when straight photography does not solve a problem of photographic illustration or persuasion.

Technique of Sandwiching: Kane has often been engrossed for hours in the search for the right color images to sandwich, for a satisfying match can never be left to chance. He begins by projecting all the slides pertinent to the multiple image he has in mind. As he

finds possibilities, he removes the film from its cardboard frame and remounts two frames together (in a plastic slide mount available at camera shops), and projects them again. When this stage is over, he has a pile of potential sandwich combinations. In the next stage he spreads the possibles on a light table and reconsiders, recombines and manipulates the small frames of film, handling them carefully with tweezers. Of this procedure he says, "It's a very meticulous, sometimes infuriating, process. If your eye and the magnifying glass are not precisely centered, the effect you wanted is not perfect when the sandwich is projected."

Once a pair of color frames has been "married," as Kane puts it, he cuts the edge of the top piece of film along the sprocket holes, fits the two exactly in register, and Scotch tapes them along the cut edge. Thus they can be parted and dusted by the engraver without shifting from the relationship Kane seeks so painstakingly. The sandwich is then set into a plastic slide mount and may also be protected in a transparent plastic sleeve.

Since sandwiching is an important—and very personal—means of expression to Kane, he has for years built a file of slides from which he can choose sunsets, clouds, fields, textures, soft-focus effects, flowers, and various natural phenomena. These are indexed and segregated for easy availability, and none is used more than once, though many are similar because the collection is large.

A DAY IN THE LIFE ELEANOR RIGBY
[page 34]

When *Life* asked Kane to do an interpretation of Beatles lyrics, he spent quite a while listening to their music, and decided to shoot in Lon-

don because of the intrinsically English character of the material. The man in the car at bottom left is sandwiched with a traffic sign and green light. The crowd scene at bottom right is a sandwich in

which the same color shot was repeated, once as it was taken and again upside down and reversed. Kane felt it offered a kind of "Rorschach effect" that amplifies its impact. The top right picture is also a sandwich representing Eleanor Rigby, using the sad face of a statue superimposed over several tombstones with flowers.

STRAWBERRY FIELDS
[page 35]

Another Beatles song seemed to invite listeners to throw off their clothes and inhibitions and be children again. Kane tried to shoot it with adult models and children; the former were too

literal, he recalls, but the children were perfect, running around and following directions beautifully. The children ran away from and towards the motorized camera many times while Kane shot with a 180mm lens. Diffusion resulted from foliage held very closely in front of the camera by an assistant. Back in his studio, Kane

sandwiched in a soft-focus image of flowers which looks homogeneous enough to have been done in a single camera exposure.

VENICE
[pages 64–65]

Here and on the following four pages are examples from a memorable series for *Look* on the sinking of Venice. They underline Kane's thesis that a photograph can transcend reality and symbolize the essence of a situation. This sandwich, inspired by Kane's wondering, "What would it feel like and look like if Venice suddenly succumbed to the sea?" remains one of his favorites. His images were shot from a ferry boat plying the bay between the city and the Lido, but he knew that conventional views would not satisfy him. He loves obvious symbols that people are used to seeing such as the Venice skyline, but he made sure to tilt his camera for some shots so that the images, when combined, gave a queasy feeling as if Venice had already been overwhelmed and was being swallowed by the Adriatic.

In preparation for this assignment, Kane had an underwater housing made which allowed him to use a variety of lenses on the Nikon he held over the edge of the boat, either partly submerged or skimming the surface of the water. In this way he got a foreground of blue along with a water-level view of the city.

In terms of exposure for this, and for sandwiching in general, Kane brackets all his pictures. From experience he has found that a normal exposure plus an overexposure (which is less dense and allows more of the other image to show through) makes for the best combination.

As he is shooting, Kane visualizes sandwich effects to

guide his shooting of a situation, but *not knowing* exactly what will happen in the final sandwich is part of the excitement that stimulates him. At the same time, he *knows* he is in control of the technique and will continue to have choices of exposures and compositions throughout the process. "I've always enjoyed the element of chance," he says, and he capitalizes on it artistically through thorough familiarity with his techniques.

SAINT MARK'S SQUARE
[pages 68–69]

Here Kane strayed from the sinking city theme to illustrate his fascination with the Piazza of Saint Mark's itself. "I wanted a tribute to the square as an incredible space, one of the most magnificent I have ever experienced, and at the same time to try to render it in terms of the Renaissance perspective drawings that impressed me." Again, duplicate images were sandwiched right side up and upside down.

LADY MADONNA
[page 72]

Another sandwiched image (also on page 33) combining a baby and an institutional type of bed was part of the *Life* series on Beatles lyrics. This one reflected a threat of abandonment in the hippie life style. The baby was photographed in a carriage, and the bed is actually in a charity home for old men. Kane deliberately merged symbols of an abandoned child and abandoned adult. Both shots were made in available light.

WEB OF STEEL
[page 84]

After a harrowing incident in the South when Kane and a *Look* writer were chased and threatened by Klansmen, he made this symbolic pairing of a young boy and an iron gate that he photographed in front of a warehouse. ''I didn't need jail bars,'' Kane explains. ''This texture was much more powerful, and I didn't want to imply that the kid was in jail, but that he has been held back. To me, it's one of the most successful sandwiches I've done in terms of tone and color, and for the way the eyes come through; it's hard to tell what's in front and what's behind.''

INDIAN
[pages 90–91]

Beginning with his feeling of affinity for the American Indian, and motivated by a *Life* story on sacred Indian sites, Kane found a model over 100 years old and posed him in such a manner that he became a mountain peak. From a low angle with a 35mm lens, Kane shot against a sky full of rain clouds; he also exposed several rolls of film with an 85mm lens for the cloud-filled sky alone, and later made a sandwich back in the studio with typical meticulous care. He designs a picture very carefully, spending a great deal of time organizing its graphic elements. ''There must be a real blend between idea and design,'' Kane says. ''A picture has to have both.''

MEDITATION
[page 93]

This series of three sandwiched images illustrated the theme of transcendental meditation as part of a *Look* story on the ''human revolution.'' Kane's pictures symbolized finding a new form of peace via solar energy that moves from the man's head to center in his gut; when it

is expelled, he springs for joy. Each of the pictures was visualized alone and in tandem before and during the photography session.

A FEW SPECIAL EFFECTS

When the extent of Art Kane's photographic technique is revealed, it is refreshing to realize how directly he executes his ideas without resorting to esoteric or expensive gimmicks. To Kane, color photography is a means to an end. He conceptualizes beyond the point to which others may go, but his tools and materials are available to anyone. ''Having a little story to tell,'' he explains, ''is an especially effective way to structure a set of images.'' In order to avoid the ordinary, any of us may try to envision picture situations in terms of mood, emotional impact or theme. Kane's imagination is the thread that ties his pictures together and saves them from being simply a series of random shots.

The following notes help explain some of the Kane images that were created in ways different from those above.

THE SQUISH
[pages 10–11]

If any of the pictures in this book might be labeled a ''trick,'' this manipulated SX-70 print would qualify. When the SX-70 camera was first introduced by Polaroid, Kane began wondering how its fast-color process worked. He removed some unexposed sheets from a pack of SX-70 film that had not run through the camera and began playing with them.

There are multiple layers of dyes under the transparent protective covering of SX-70 film. When pods of chemicals at one end are squeezed open as the film runs through rollers in the camera, the chemicals are spread evenly over the dyes to form a picture image. Kane discovered that he could force the chemicals out of the pods and onto the film with a fingernail or a paper clip, after which ''I just squished the chemicals around and watched rather abstract images form before my eyes.'' Included in the film is a layer that prevents light from fogging the picture as it develops outside the camera, which makes hand-manipulation of the chemicals possible.

''You can press sections of the pods one at a time to control the flow,'' he explains, ''so what you're doing is creating an image by means of the pressure applied and the direction of your finger or whatever device you use to spread the chemicals. You can also do this after taking a picture with the SX-70, by running a finger or the back of a spoon over the print to make impressions within it and alter the normal development pattern. In this way, you can actually redraw or influence the entire photograph, blending colors, changing expressions or whatever.''

This variation is not exactly what Dr. Edwin Land, Polaroid's presiding genius, had in mind for his process, but you might give it a try.

AMERICAN FLAG
[pages 12–13]

Kane saw the flag as a body of land, and remembered a hill behind a house he once rented in Connecticut. He knew that with the extreme depth of field of a 21mm lens he could photograph a flag stretched between two poles that didn't

show, and include a group of children on top of the hill about 75 feet away. First impression may indicate that this is a sandwich, but if you look closely, you'll see through the flag. It has been Kane's most widely published picture.

MANHOLE
[page 27]

This is a true montage made by stripping a cutout color print of the hands onto a color print of the manhole cover. Kane did not start to do the picture this way (to illustrate Dylan's ''Subterranean Homesick Blues''), but Con Edison would not allow him to risk the life or limbs of a model who might be crushed by an extremely heavy manhole cover. So Kane shot the cover in a street by subdued light, and made another picture of his assistant's hand reaching over the edge of a piece of curved cardboard in the studio. A color retoucher put the two color-print images together.

Similar effects can be created with black-and-white prints by careful placement. The edges of the pasted-on picture must be tinted to blend realistically with the background.

NEW YORK ARTISTS
[pages 42–43]

When Kane was asked to interpret the work of five New York artists for *Zeit* magazine, the assignment included Cy Twombly, who was out of town. Kane found a

way to place Twombly (and his friend Robert Rauschenberg) in New York anyway. He began by placing a snapshot in various locations, such as on a wall with grafitti, or in a telephone booth; while walking the streets, he came upon a stack of newspapers. Kane simply slipped the color snap under the twine, where it fitted neatly, and made this shot on Kodachrome.

TREE
[pages 70–71]

The "special effect" here is based not on technique but the influence of painting. In Jerez, Spain, Kane came upon a solitary street in late afternoon which reminded him of a de Chirico painting. In addition, the tree seemed to resemble a reaching hand; aspiration is a recurrent theme in some of Kane's imagery.

The flat pattern of a Mexican street scene on page 62 echoes the geometry of a Mondrian composition. All of this points up the importance of graphic and visual literacy for today's alert photographer.

FREEDOM MARCHER
[page 86]

In Atlanta to work on his "Songs of Freedom" series, Kane posed a model on a painted line in the street. Bracketing produced this low-key image, with basic exposure made for the flesh tones. Such a photograph is a challenge in subtlety. Kane says, "I worry often that color

will be too pretty or too theatrical. I felt I was safe here because of the overcast sky and the dark colors, but it's so easy to be corny or overdo color because it's there and film records it so literally." Understatement can be effective, especially since novices tend to choose subjects that are a blaze of color.

Although Art Kane is relatively unimpressed by the technical aspects of his work, he has an innate respect for the equipment he has chosen, and he handles it with deft versatility to execute his striking ideas. Few professionals have the time or inclination to be gadgeteers, but almost all experiment and explore the tools and materials familiar to most of us. Kane feels the responsiveness of his film and the latitude of his lenses with an instinct that comes from artistic intelligence and lengthy experience. His imagery is often subtle, and he is a ruthless editor of his own pictures. Here is a significant thought to conclude this section:

"No matter how difficult it's been to get certain pictures, you can't let that affect your taste as you make decisions about which ones to keep. You must develop a willingness to discard slides or prints on which you've worked very hard, if they don't measure up. A lot of people may say, 'That's not the world's best picture, but I sure did sweat over it, so I'll keep it in the showing.' Those people are their own worst enemies. It's better to throw everything away and start over. Go for a hundred percent of perfection and you might wind up with eighty-five; too many people seem to go for fifty and wind up with thirty."

Like Kane, you need to be intolerant of anything mediocre if you expect the excellence that makes photography worth while.

Do you want war or peace? Kane asked Look *readers with an image whose power depends largely on its simplicity—an image he made only after discarding several earlier attempts on which he had spent much effort.*

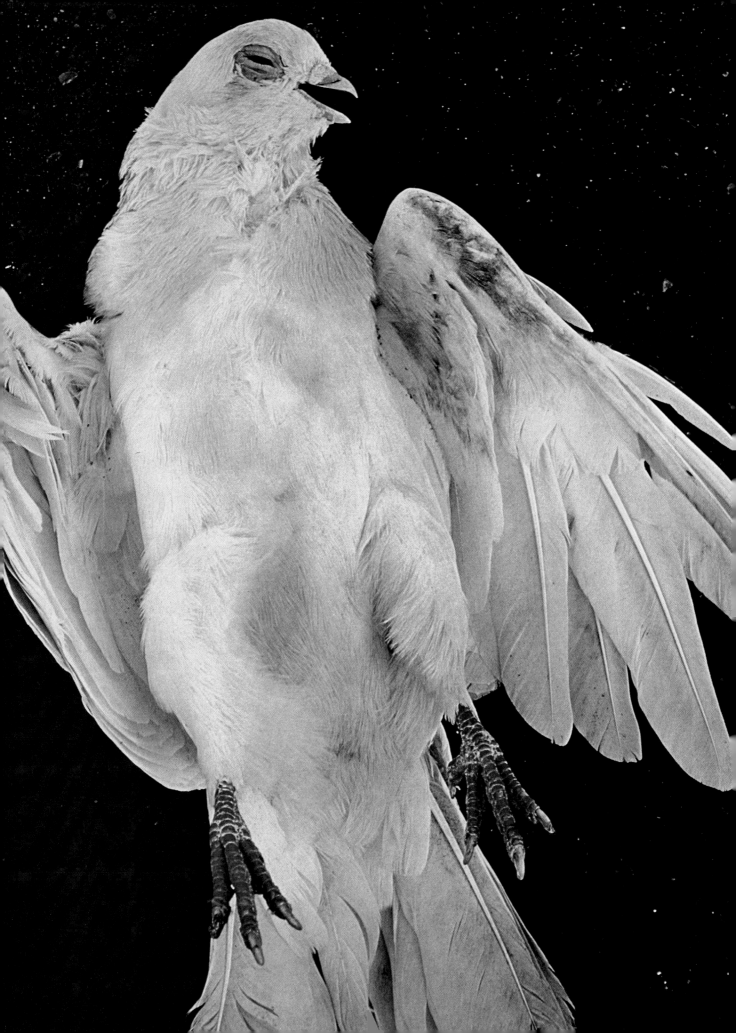

Persuading: The Power of Simplicity

A letter to the editor from one of the 34 million readers a *Look* issue reached in 1968: "... I was outraged by your letting Art Kane say our chances for peace are dead. But I could not erase his picture from my thoughts. I kept going back, unwillingly, to open your magazine and look again. Now it says something new to me, that this is what we *will* have if I don't act, along with my husband and neighbors, to keep the dove alive. Thank you, Mr. Kane...."

There is no way to count how many other minds Kane's photographs have changed. Yet the pictures that he calls "propaganda" have contributed to some of the human triumphs of the past 15 years.

Assigned to illustrate the major political issues of the 1968 presidential campaign, Kane pondered the chaotic effects of the war in Vietnam. He had a plaster of Paris American eagle, a flagpole ornament, and decided to smash it. The weather outside was cold, so he arranged the picture in his Carnegie Hall studio. When an assistant brought him the results, he sighed. The transparencies in his hand showed a studio still life, clever but predictable. "In fact it isn't even that clever, is it?" he said. "It's pretty corny. We've been lazy. Let's take the thing out in the street." Outdoors he was a bit more pleased when a few autumn leaves blew unexpectedly into the picture. Still, no good.

"Come on," he said to himself. "Why deal with plaster? Let's get down to the nitty gritty, let's kill off the old bird of peace." He called All-Tame Animals. They sent over a live dove with a man who suffocated it on the spot. Kane had not expected that, but he managed to take the dove down to Central Park and stand over it with a 35mm lens, exposing for white feathers (previous page)

One source of Kane's power is a certain brutality with his own pictures. "Sometimes," he says, "you have to choose between turning in the best you could do, even if you don't like it, and turning in nothing, which is horrendous. Considering the number of images I'll produce in a lifetime, I'd have to be out of my mind to expect every one to be perfect. Still, if I discover I haven't succeeded, there is only one thing to do. Try again to succeed. Once I have it, I just throw the other stuff away."

Another source of power is his tendency to reduce ideas to common denominators. When *Esquire* called him to illustrate "The Champ at 50," an article about Joe Louis, the editors asked Kane to follow the former boxer around New York and make a portfolio of pictures. "I'd rather sum him up in a

From "Songs of Freedom" (at left). At right, the portrait of Joe Louis.

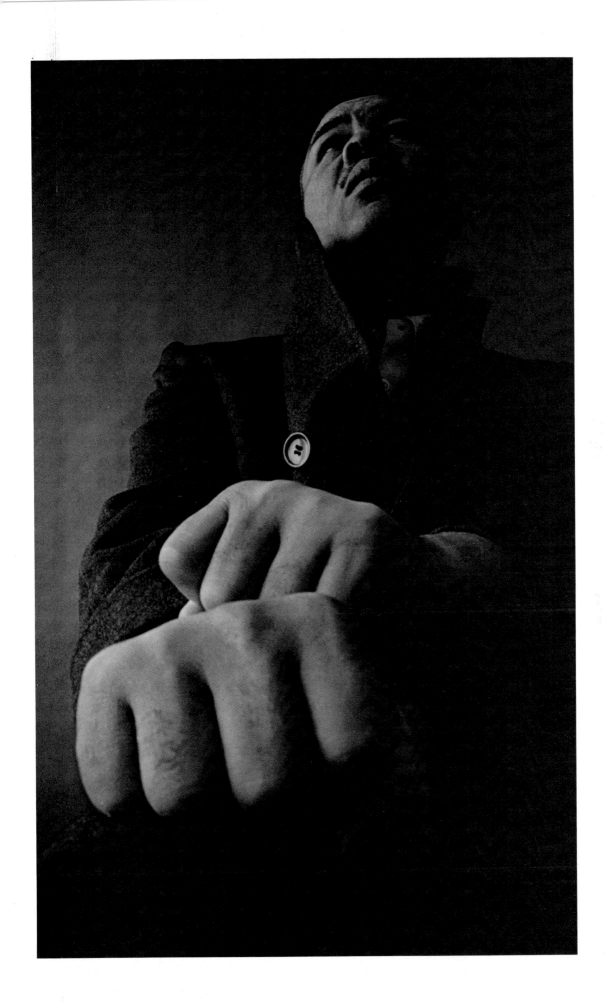

portrait,'' Kane said.
''Ask him to come up to
the studio.'' He remem-
bered that in 1937, the
year he took his first ill-
fated flag picture, Louis
took the heavyweight
championship and
looked, to a 12-year-old
boy, like the strongest,
most beautiful man in
the world. To the mem-
ory of that strength Kane
wanted to add his own
hope for the strength of
black Americans who
were accomplishing a
revolution in the nation's
racial attitudes.

When Louis arrived,
wearing a heavy over-
coat, he heard Kane's
idea for the portrait: ''I'd
like you to strip to the
waist and make it obvi-
ous that you're sucking
in your gut, so the pic-
ture says to the world,
'I'm not what I used to
be, but I still have my
pride.' ''

''No,'' Louis said. ''I
don't want to show my
body any more.''

''I know, Joe, but let's
try and make it look as
heroic . . .''

''No.'' The voice was
quiet. ''I really don't
want to do that.''

Kane reproached him-
self for pressing the
point. Recovering fast,
he realized that an even
better portrait would be
the reverse—Louis bun-
dled in his coat with the
source of his pride, the
fists, out for the world to

*Symbolism in a montage
(right) and in a straight stu-
dio shot (far right) calls out
the same message.*

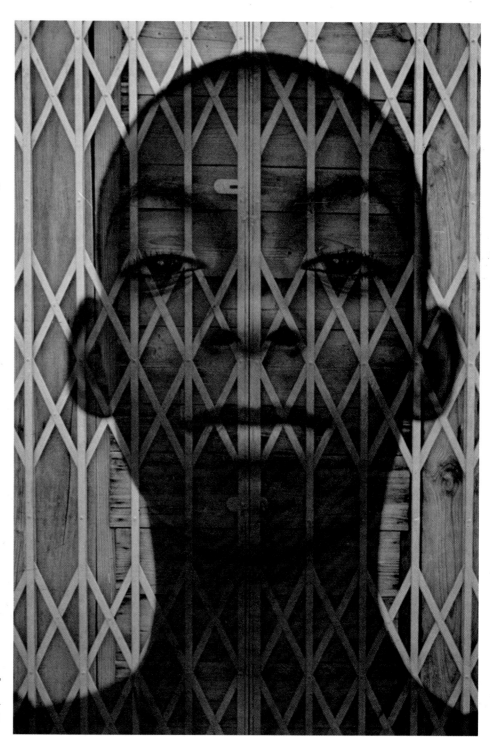

84

Fragility and controlled anger: part of a story on dolls for Life.

see. The idea might not have come if Kane had not, three days earlier, bought his first Nikkor 21mm lens.

"Joe," he said, "would you look up, as if you're appealing for strength? Great." He got down low to make the fists look like bombs, in what he still regards as "the most intelligent use I've ever made of that lens" (page 83).

A year later, Kane's involvement in the civil rights movement took him out of the studio on a nearly fatal trip to Bogalusa, Louisiana, but the resulting pictures show a distillation of experience, not the raw material. Allen Hurlburt, who knew Kane loves illustrating music, called to ask for an essay to be titled "Songs of Freedom" for a *Look* issue on the South. After listening to records of the songs emerging from marches and sit-ins, Kane set to work. The hand of an actor holding a truncheon, posed on the roof of Carnegie Hall, makes a terse comment on the role of Southern police when placed beside the vulnerable skull of a young man (page 82). The face of the same young man, exposed normally for dark skin and eyes, appears with a curtain of steel (left) in "one of the most successful sandwiches I've ever done." Kane photographed the metal lattice in front of a New York warehouse, sensing that its texture was more powerful than any predictable prison bars: "I didn't want to imply that the kid was in jail, but that he has been held back. It's an obstruction." For the montage he used a slightly overexposed transparency of the steel curtain, thin enough to let the eyes come through and make it hard to tell what is in front and what is behind.

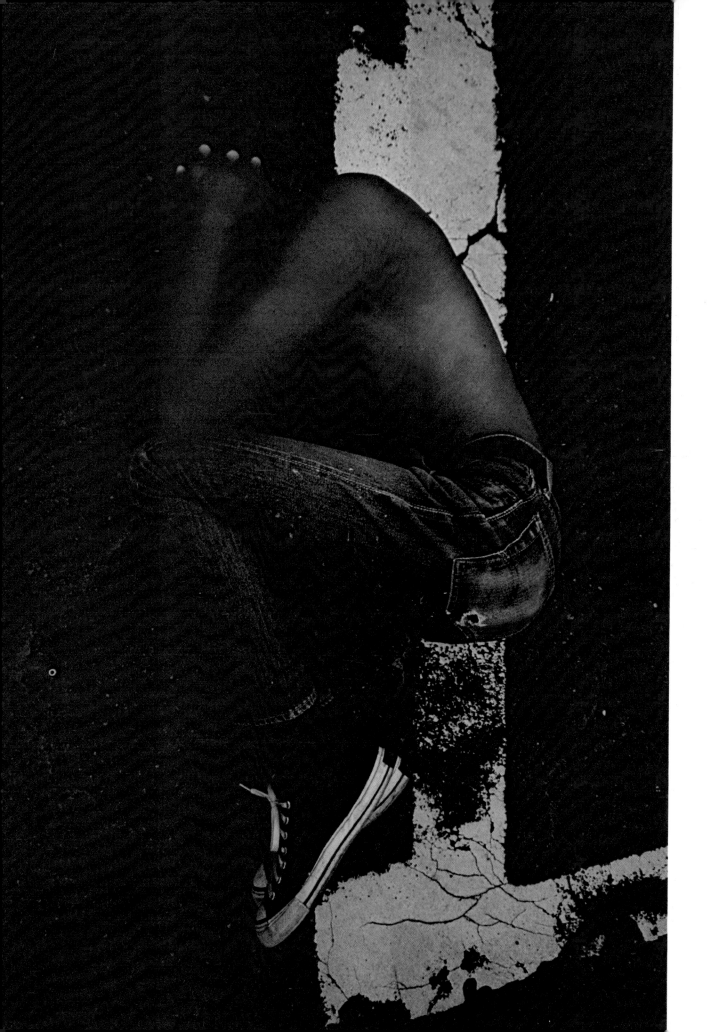

Still in the studio but working momentarily for a different magazine, he conceived a different approach to bondage (below) for a *Venture* article on apartheid in South Africa. The model was a dancer, booked because Kane knew the pose would demand a flexible body that could sustain what was really a form of torture—getting into position, keeping it while Kane wrapped the cord around him, and being sure not to sag and loosen the binding during shooting. Available light on seamless paper removed the model from time and place.

For *Look*'s "Songs of Freedom," however, Kane did not travel entirely in his imagination. He had wanted to make some or all of the pictures during a trip with writer Christopher Wren into "the heat of the battle," suspecting that he might be ready to change his ways and photograph the real thing instead of its symbols.

Their first stop was Bogalusa. Kane and Wren had parked their rented car in a square near a restaurant where a sit-in was in progress and walked a few feet when they heard the chilling question, "Where y'all from?" delivered by one of a half-dozen men surrounding them. Glancing at Kane's cameras, the man added,

An overcast day in Atlanta softened shadows for this "Songs of Freedom" illustration.

"You boys better get back in that car and get the hell back to New York, or we're going to kill you."

Wren did not like the look of the empty square and the fact that three automobiles, each one flying a Confederate flag, had pulled up across the street as if waiting for the outsiders to make the first move. After hesitating a few minutes, Kane and Wren started out of town. Weaving their way to the highway, they found themselves going 12 miles an hour behind one of the Confederate cars. After several hundred yards it forced them off the road.

Kane glanced at Wren, a former Special Forces trooper, and for the first time saw fear. "Lock your door!" Wren shouted. As Kane pushed the button a Coca-Cola bottle smashed the windshield. Wren gunned the car, scattering the knot of men converging on it. He lost the Confederates on a 50-mile race to the New Orleans, but he had to steer with his head out the side window: the bottle, stuck like a bazooka shell through the windshield, blocked his view.

Before they turned in the car to Hertz, Kane took a black-and-white photograph of Wren behind the wheel. It shows a pleasant-looking young man, the bottle, and a beautiful pattern of cracked glass—little reflection of the most terrifying moment of Kane's life.

Once again reality had not lived up to itself visually. "What's happening at any given moment," Kane insists, "isn't what you really *see*. You edit, while it's happening and later in memory, to leave out the little peripheral things and emphasize the big powerful things." He returned to photographing symbols, producing images all the more persuasive for being stripped to essentials. For the image at left, that meant posture, skin color, clothing and street. Since civil-rights activists were taught to fall into a fetal curl to protect themselves when attacked, the posture summed up for Kane much of the implacable and nonviolent nature of the movement. He was commenting on the situation of blacks, not whites; a shirt would not only have reduced the impression of vulnerability but also covered most of the identifiable skin. "Naked would have been beautiful. Then I'd have had pure symbol. But, that being a bit out of the question, I just asked him to remove his shirt." Worried that the picture would be too pretty, Kane suppressed

the theatrical colors of bright white street paint, brown skin and blue jeans by underexposing. He knew the image would darken a little more in reproduction as ink soaked into the page.

It happens that he shot the picture on page 86 on an Atlanta street a week after Bogalusa, but it could have been anywhere. He set it up to contrast with the illustration he knew he was going to make for the song "We Shall Overcome." It would say of course that a child is born without prejudice, but say it with some irony by casting a typical Ivory Snow white baby in a typical calendar picture with another baby just as cute, and black. A long casting session in the studio narrowed dozens of babies down to six whites and six blacks. Kane tried different combinations until the two at right got interested in each other. As they played in natural light on seamless paper, he did not touch them. At the moment the black baby turned away from the white in the middle of an exploratory touch, Kane felt he had his statement. "Blacks have been extending themselves for 300 years," he spells it out, "and whites turned their backs. Now, Mr. White Man, for Christ's sake why don't you check them out? And if they don't embrace you in the beginning, consider what you've put them through."

Two carefully cast babies
on seamless paper for "We
Shall Overcome."

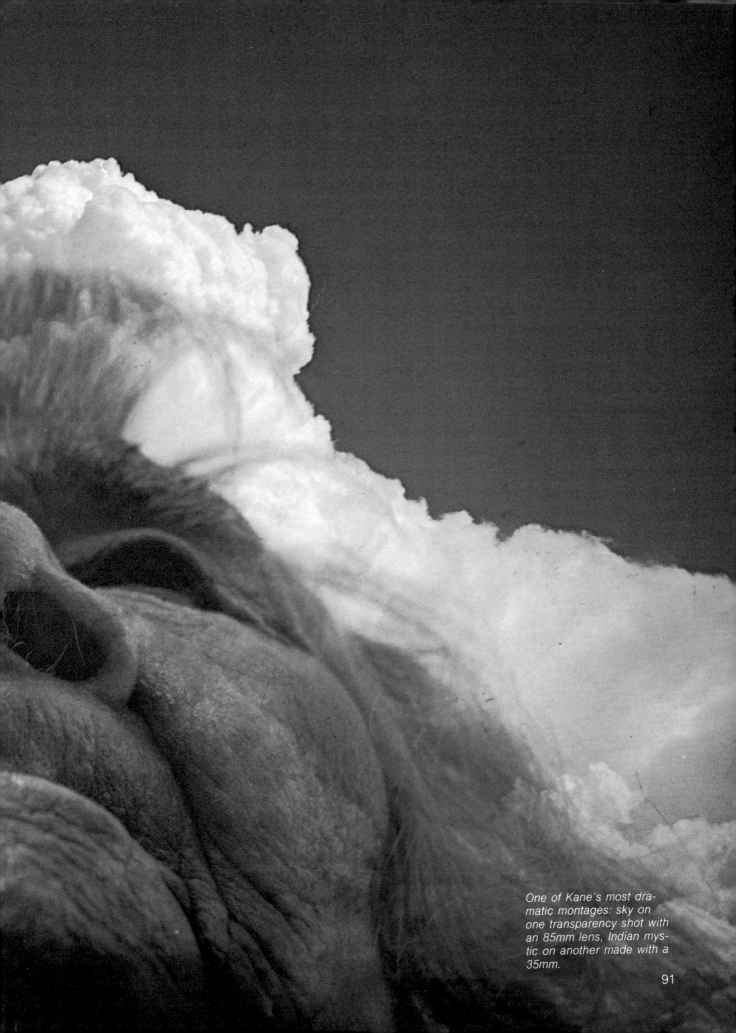

One of Kane's most dramatic montages: sky on one transparency shot with an 85mm lens, Indian mystic on another made with a 35mm.

91

Design: Putting Flesh on the Spirit

The baby picture astounded *Look*'s audience, especially the whites, and for a while Kane remained proud of it. Ten years later, however, getting up from beside the fireplace in the country house to fix another cup of tea, he is restless.

"It meant a lot at the time because of the idea," he says, staring round-eyed at it. "To me at this point it looks like what I was parodying, a piece of calendar art. I hate being part of that kind of sentimentality. I guess sometimes you just do it because it's going to have an effect. It was worth the effort for that. But now that the issue is no longer as volatile, it has become nothing more than a corny picture."

The seeker in Kane keeps fighting to burst out. His flight from home, his abrupt changes of working habit, his brusque rejection of photographs he once liked, his search for something that looks better than the real world, are all parts of a pattern that emerges, finally, in the yang and the yin of the man's interlocking outer and inner selves.

Out at the fingertips is the form of things. "I can never accept a picture of mine that contains the idea I am after but is designed badly.

One without the other is no marriage." There speaks the Kane who will not make multiple images in the camera—knowing all along that plenty of fine color photographers, Ernst Haas eminent among them, do so—because he can control *his* effects better outside it, the Kane who refuses to shoot if the light is a little off.

Inside somewhere is the function of things. What are we all doing here? Kane's search for an answer to that one keeps him from embracing any dogma, except that there is a spirit in us that can at moments be evoked.

He is positive that he came into contact with some unifying spirit during the three weeks in 1971 that he spent photographing sacred places of American Indians for *Life.* Dorothy Sieberling, the editor in charge of the project, outlined the premise: Sanctified by legends and ancient faith, mountains and lakes and canyons reflect the Indian belief in unity between humankind and nature. His growth had led him in the previous seven or eight years to Eastern religions, to Esalen Institute on California's Big Sur coast, to reading Teilhard de Chardin and other mystical philosophers. He had always loved Indians anyway: "To hell with the cowboys. In the movies, when those Indians appeared against the horizon, my heart used to skip."

Outside Flagstaff, Arizona, Kane was taken to a sacred Hopi site, a peak in the San Francisco Mountains. What he saw was a ski tow and a lodge that sells hamburgers. But this is still the place where the kachinas, the Hopi gods,

appear once a year. What the place means to the people who pray and dance there goes so far beyond externals that a photograph of the peak itself would only diminish the truth. He had been reading steadily for several weeks (homework being almost a religion with him), and had begun to understand that, unlike the white man, the American Indian does not separate spiritual life from material life. A friend of Ernst Haas had introduced Kane to one of the oldest living Hopi, a man who lived in the remote Third Mesa where no white ways had penetrated, and for four days they sat together before the man would speak with him. Kane recorded the words of others who did speak, then listened to his tapes at night. At length, when the old man said during a conversation, "I am the land and the land is me," Kane saw that he could suggest the natural cycle in one picture. He would photograph the Indian as a mountain.

He asked the old man to stand up. Kane dropped to his knees and aimed a 35mm lens up at his face and the clouds above. The finished picture (preceding page) is a sandwich that restores the actual appearance of that moment. The 35mm lens, of course, diminished the real clouds to specks; Kane quickly photographed them with an 85mm lens, knowing that nothing in his special-effects file at home could match them. "Sometimes when you get into an environment you realize why things happen," he wrote in his notebook that evening. "They pray because the sky and the clouds here are so awesome."

Earlier, for *Look,* Kane had illustrated an article called "The Human Revolution," dealing with the search by some Americans for new understandings of themselves in the universe. Among the techniques that had begun replacing drugs as guides in the quest were meditation and encounter. Kane's problem was how to show that.

He could have photographed a meditator—"But what's that? Just a guy with his eyes closed." He returned to Esalen, where he had been before on his own private quest, for a series of pictures that say "Transcendental Meditation" for Kane (right). Where does this new energy come from? The East, where the sun rises. What does it tell us? Get out of your head, into the center of your being, and if you can do it you will transcend. Symbol by symbol, he put it together. First he photographed Joel Kramer, one of Esalen's yoga adepts. Then he sandwiched the transparencies with sea and sun from his files, following the path of the energy until the mythic meditator, liberated, leaps for joy.

A climax of some encounters at Esalen is the lifting ceremony, a truly joyful ritual for the people involved. Kane made photographs of an encounter there, and they fell flat. They showed nothing of this phase of the human revolution, this new brotherhood. Back in New York, he called in a group of friends, took off his clothes along with them to make the studio comfortable, and staged a lift. Shot with a wide-angle, turned sideways and superimposed with a sky, it became a flying thrust forward (pages 94–95)

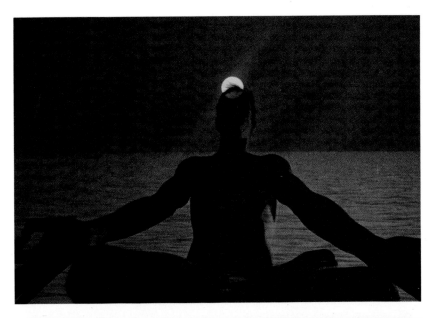

Design puts flesh on these flashes of spirit—but only when the technique does not show. "I'll throw away anything that's obvious," Kane promises. "If you look and say, 'Oh, I know how he did that,' then the technique becomes a ploy." He dared to skim very close to that problem in a furious portrait made 25 years after the atomic bombs fell on Japan. When he went to Hiroshima and met some victims of that event, he saw scars and distorted faces, "but nothing that came up to the real horror of what happened." Day after day, though, he kept noticing the Imperial flag. The red circle haunted him, until he resolved to strip it into a picture of the pupil of a child's eye, making a satanic image that combines the symbol of the old Imperial Japan with a suggestion of the bomb's fireball (page 96).

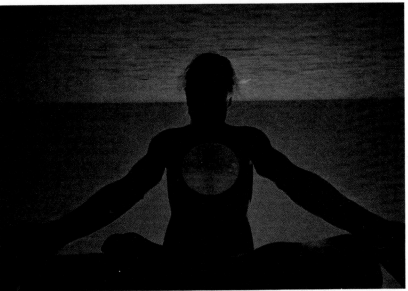

Results can satisfy him for a while, but the boy who saw what was really at the top of the flagpole is still restless. The tools of photography are familiar now, no longer frightening, but maybe for Kane that is not so good. Maybe that is why—even with his new studio and the resumption of a rich career—he wonders if he shouldn't try something else. Writing, perhaps.

"What I miss at the moment," says the man who made these images, "is the excitement of a child with a new toy. I should like to be playful and naïve and inquisitive again. I should like to discover a new technique, or as I prefer to think, I should like to discover a new idea."

Sandwiching makes the point about meditation (right) and the thrust of an encounter group (over).

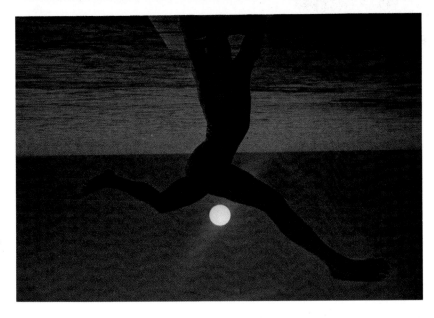

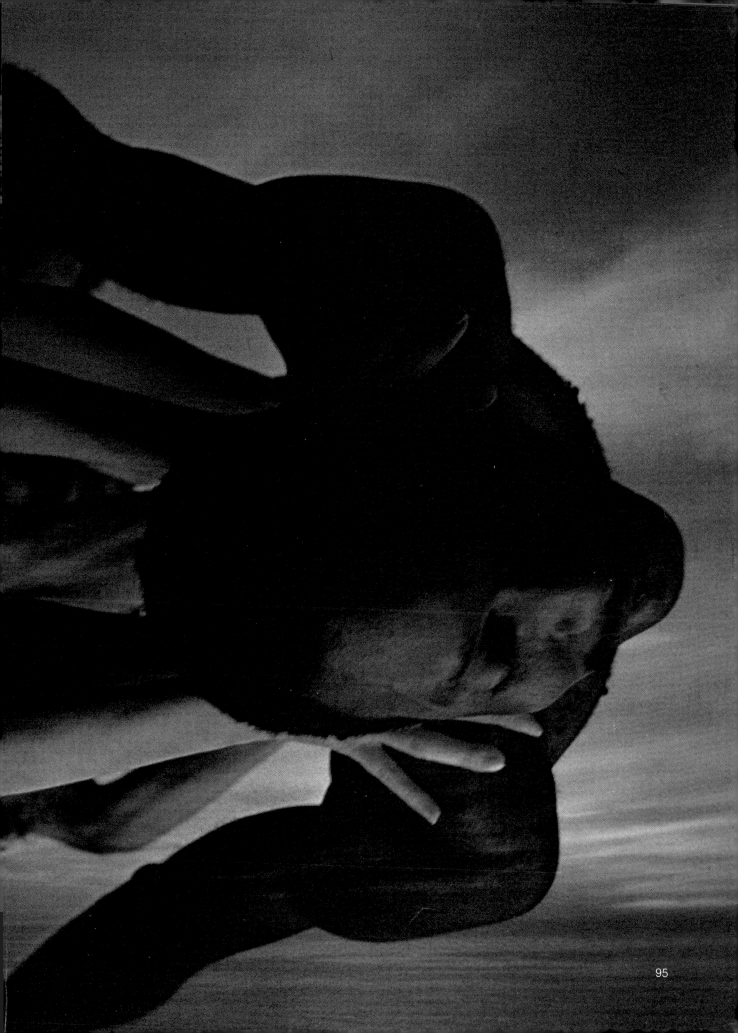

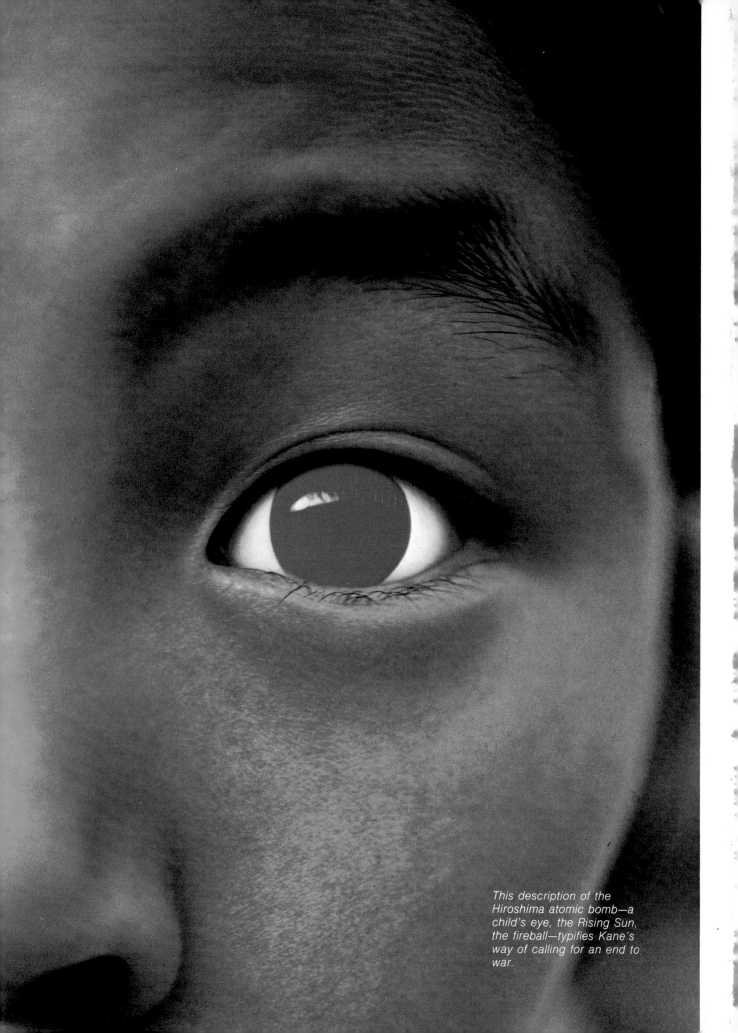

This description of the Hiroshima atomic bomb—a child's eye, the Rising Sun, the fireball—typifies Kane's way of calling for an end to war.